Comparative Dynamics in the Comics Industry

Due to the enormous cultural and economic impact of the Marvel movies, manga, and anime, research on the comics industry is growing, but has focused primarily on the US and Japan. This book focuses on the European comics industry to explore the complex impact of organizational and cultural differences in audience behaviours, both in the comics industry specifically and in the creative industries in general.

Drawing on the author's research on the contrasting comics culture of the Netherlands, Belgium, and France, the study uses institutional theories and organizational ecology to compare the interactions of publishing organizations with artists, audiences, and each other. It combines this with a critical approach to modernization theory to evaluate how historical, cultural, and religious factors might impact the audience for comics and how those audiences respond to and interact with this specific creative medium. The book demonstrates the benefits of using combinations of theoretical frameworks to draw out more nuanced interpretations for this and other under-researched creative industry areas.

With its unique insights, this book will be of great interest to researchers in the comics industry, as well as a fascinating contribution to research in cultural-related audience behaviour for all scholars in the creative industries.

Rudi de Vries is a Lecturer at the Faculty of Arts and at the Faculty of Economics and Business at the University of Groningen, the Netherlands.

Routledge Focus on Business and Management

The fields of business and management have grown exponentially as areas of research and education. This growth presents challenges for readers trying to keep up with the latest important insights. *Routledge Focus on Business and Management* presents small books on big topics and how they intersect with the world of business research.

Individually, each title in the series provides coverage of a key academic topic, whilst collectively, the series forms a comprehensive collection across the business disciplines.

Open Strategy for Digital Business
Managing in ICT-Driven Environments
Ewa Lechman, Joanna Radomska and Ewa Stańczyk-Hugiet

Purpose-driven Innovation Leadership for Sustainable Development
A Qualitative Case Study Approach
Gaia Grant

Evolution of the Global Fitness Industry
Strategy, Sustainability and Innovation
Patrizia Gazzola, Enrica Pavione and Francesco Ferrazzano

Digital Transformation of Performing Arts
Trends in the Classical Music Industry
Salvino A. Salvaggio

Globalization and Entrepreneurship
Cases from China, Japan and Bangladesh
Mirjana Radović-Marković, Yao Ouyang, and Md. Shajahan Kabir

Comparative Dynamics in the Comics Industry
Contrasting Cultures in France, Belgium, and the Netherlands
Rudi de Vries

For more information about this series, please visit: www.routledge.com/Routledge-Focus-on-Business-and-Management/book-series/FBM

Comparative Dynamics in the Comics Industry
Contrasting Cultures in France, Belgium, and the Netherlands

Rudi de Vries

LONDON AND NEW YORK

First published 2025
by Routledge
4 Park Square, Milton Park, Abingdon, Oxon OX14 4RN

and by Routledge
605 Third Avenue, New York, NY 10158

Routledge is an imprint of the Taylor & Francis Group, an informa business

© 2025 Rudi de Vries

The right of Rudi de Vries to be identified as author of this work has been asserted in accordance with sections 77 and 78 of the Copyright, Designs and Patents Act 1988.

All rights reserved. No part of this book may be reprinted or reproduced or utilised in any form or by any electronic, mechanical, or other means, now known or hereafter invented, including photocopying and recording, or in any information storage or retrieval system, without permission in writing from the publishers.

Trademark notice: Product or corporate names may be trademarks or registered trademarks, and are used only for identification and explanation without intent to infringe.

British Library Cataloguing-in-Publication Data
A catalogue record for this book is available from the British Library

ISBN: 978-1-032-35717-1 (hbk)
ISBN: 978-1-032-35718-8 (pbk)
ISBN: 978-1-003-32817-9 (ebk)

DOI: 10.4324/9781003328179

Typeset in Times New Roman
by Taylor & Francis Books

Contents

List of illustrations vii
About the author viii
Acknowledgements ix

1 Introduction 1

2 Comics industries 5

 2.1 Introduction 5
 2.2 Comics in France, Belgium, and the Netherlands 6
 2.2.1 Historical developments 6
 2.2.2 Comics sales after 2006 11
 2.2.3 Readers of comics 12
 2.2.4 Production of comic albums 14

3 Theory 19

 3.1 Institutional logics 19
 3.2 Organizational ecology 20

4 Data and methods 23

5 Findings 28

 5.1 Introduction 28
 5.2 Case studies 28
 5.2.1 Dupuis (Belgian de alio, Walloon) 28
 5.2.2 VNU (Dutch de alio) 31
 5.2.3 Glénat (French de novo) 32

 5.2.4 Oog & Blik (Dutch de novo) 34
 5.2.5 Bries (Belgian de novo, Flemish) 35
 5.3 Cross-case analysis 36

6 Discussion 43

7 Conclusions 45

Appendix I: The role of religion in the reading of comics 48
Appendix II: The many roles of Joost Swarte 53
Index 61

Illustrations

Figures

2.1	Changes in reading of comic albums, in percentages of total population	13
2.2	Title supply of Dutch and French language comic albums in the period 1985–2009	14
5.1	De alio and de novo publishers of comics albums (1858–1994)	29
5.2	Proportions of de alio and de novo publishers of comics albums (1945–1994)	29
A.I	Reading comics and religion	50

Tables

2.1	Comic album sales in 2006; France, Belgium, and the Netherlands compared	10
2.2	Readers of comic albums	12
5.1	Logics and characteristics of de alio and de novo comics publishers	37
5.2	Practices of de alio and de novo comics publishers	38
A.I	Reading comics and religion: differences within and between countries	51

About the author

Rudi de Vries is a lecturer at the Faculty of Arts and at the Faculty of Economics and Business, University of Groningen, the Netherlands. He received his PhD from the Faculty of Economics and Business with interdisciplinary research into the long-term interaction between comics and comics publishers in the Netherlands and Belgium. De Vries has presented parts of his research at conferences in Berlin, Bergen, London, Prague, and Liège, and has published several articles derived from his dissertation. He served as a member of the board of Het Nederlands Stripmuseum (the Dutch Comic Art Museum) in Groningen in the period 2002–2009, and he writes occasionally for the Dutch comics information magazine *Stripschrift* and the Dutch website on comics 9e Kunst (9th Art). His research interests include institutional logics and strategies within the cultural industries and arts organizations.

Acknowledgements

I would like to thank Rieneke Slager and Sara Strandvad for their moral and practical support, the GEM department for their financial support, Stephanie Clauson for editing the manuscript, Joost Swarte for his kind permission to use his drawing *Comix Factory*, Routledge's Terry Clague and Naomi Round Cahalin for their flexibility and advice, the two anonymous reviewers who gave me feedback on an earlier version, and all people whom I interviewed or obtained information from in other ways.

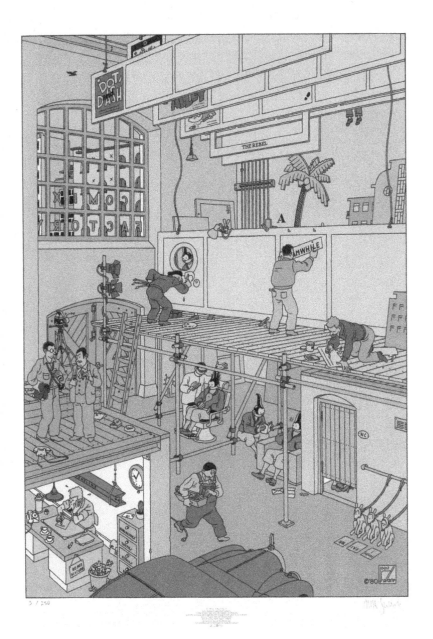

Comix Factory, by Joost Swarte (1980), an adapted version of the drawing that was used as a cover for Raw magazine.
(With kind permission of Joost Swarte)

1 Introduction

As a medium, comics can take many shapes, and for that reason they can be difficult to define. Comics are related to books and magazines, but, due to the combination of images and narrative elements, they also show similarities with visual art and film. Moreover, the nature of comics differs enormously by country.

One of the most striking developments in comics in recent decades is how they have evolved from a neglected, often even derided, mass medium for children to a cultural artefact valued by adults in many market niches, with the potential to be perceived as legitimate works of literature and art. In a number of countries, this shift has also led to a change in the characteristics of comics publishers.

Comics publishers are active worldwide as part of the global creative economy, but in popular media the focus is all too often on comics produced in the US and Japan. The US has received attention in recent decades mainly because of the success of the long series of Marvel movies derived from the much older Marvel comics, while Japan's comics fame is largely due to the popularity of anime—animated TV series and movies that are often based on manga, or Japanese comics. Manga series have also been translated and exported to other countries with increasing success, not only within Asia but also to the US and Europe.

The focus on these two countries suggests that comics are the particular domain of continents other than Europe, but this is far from the truth; in reality, Europe has its own very rich comics culture and history. Although even within Europe there are enormous differences between countries regarding their comics traditions, two countries have played especially important roles in developing what might be called 'the continental European comic book': Belgium and France.

Because Belgium is bilingual, with French- and Dutch-speaking parts (Wallonia and Flanders, respectively), and has France and the

DOI: 10.4324/9781003328179-1

Netherlands as its immediate neighbours, there have been continuous cross-border interactions between Belgian, French, and Dutch comics and their producers—both artists and publishers. Moreover, the Netherlands also has its own comics tradition, and for this reason it will be included in the comparisons discussed in this book.

Comics publishers belong to the cultural industries. These organizations have to cope with what Lampel, Lant, and Shamsie (2000) call a fundamental 'balancing act' (263): a continuous tension between creative and economic forces. In addition, like organizations in other industries, they are challenged by external and internal dynamics which complicate their ability to make sense of these developments and translate them into a clear strategy. Nevertheless, many organizations find ways to deal with this variety of changing demands. The institutional logics (IL) perspective proves to be fertile ground for organizational research on this domain.

IL can be defined as 'the socially constructed, historical patterns of cultural symbols and material practices, including assumptions, values, and beliefs, by which individuals and organizations provide meaning to their daily activity, organize time and space, and reproduce their lives and experiences' (Thornton and Ocasio 2008, 101). IL research focuses on the organizational use of multiple, sometimes conflicting, logics (Almandoz 2014; Battilana and Dorado 2010; Besharov and Smith 2014; Glynn and Lounsbury 2005; Jones et al. 2012; Kodeih and Greenwood 2014; Thornton 2004).

For research into the comics industry especially, the mutual influences between mainly market-oriented organizations and artist-oriented organizations constitute an interesting topic. The stream of IL research (including the above-cited sources) has led to insights on this topic and on organizational adaptability. However, little is yet known about the differences regarding logics between organizations in the same field and the extent to which these can be explained by the background of these organizations. This book contributes to filling this gap by examining one aspect of that background—the origin of an organization—and relating it to the logics of the organizational type at both the firm and field levels.

Organizations originally founded to function in another field may have different logics to organizations that have always functioned in the same field. Here, it is useful to consider the lens of organizational ecology (OE), which studies the diversity of organizations in a population, with organizational origin as a specific dimension of such diversity. OE researchers use the label 'de alio' to refer to organizations founded in another field and 'de novo' for organizations founded in the

focal field (Carroll, Bigelow, Seidel, and Tsai 1996). According to Hsu and Hannan (2005), the ratio of these types of organizations in a niche characterizes its identity. Perretti, Negro, and Lomi (2008) take a somewhat broader view: according to them, the legitimacy of de alio and de novo organizations in a niche is ultimately based on validation by external audiences. However, thus far these findings are based on only a few industries. This book focuses on a new organizational field—the comics publishing industry—and also pays attention to the interaction between individual firm and field.

The main research question of this book is: to what extent does organizational origin impact institutional logics in the comics industry? Specifically, the book analyses processes of comics publishers in France, the Netherlands, and Belgium in the period 1945–1994. This period was chosen because of the institutional dynamics in the comics publishing field that accompanied changes in the composition of its population and its audiences.

The following chapter contains a concise historical description of the comics industry in each of the three studied countries. Subsequently, the chapter will describe the present situation, paying attention to the numbers of readers and buyers of comics in the three countries, as well as their production of comics.

Thereafter, the theory chapter introduces the relevant concepts from IL and OE and relates them to each other. Subsequently, the method and the data are introduced. The findings section includes a quantitative part, which will give an overview of the shifts in the proportions of de alio and de novo publishers during the chosen period, and a qualitative part based on case studies of five comics publishers.

Next, the book will examine the causes and consequences of differences among France, Belgium, and the Netherlands by analysing the roles of different types of publishers and their interactions with each other, with comics artists, and with audiences. A more detailed comparison will be made using a database including all publishers in the Netherlands and Belgium since the first comics were published there.

After the discussion of the findings, the book ends with conclusions, including limitations and recommendations for future research.

Bibliography

Almandoz, J. 2014. 'Founding teams as carriers of competing logics: When institutional forces predict banks' risk exposure.' *Administrative Science Quarterly* 59: 442–473.

Battilana, J. and S. Dorado. 2010. 'Building sustainable hybrid organizations: The case of commercial microfinance organizations.' *Academy of Management Journal* 53: 1419–1440.

Besharov, M.L. and W.K. Smith. 2014. 'Multiple institutional logics in organizations: Explaining their varied nature and implications.' *Academy of Management Review* 39: 364–381.

Carroll, G.R., L.S. Bigelow, M.L. Seidel, and L.B. Tsai. 1996. 'The fates of *de novo* and *de alio* producers in the American automobile industry 1885–1981.' *Strategic Management Journal* 17: 117–137.

Glynn, M.A. and M. Lounsbury. 2005. 'From the critics' corner: Logic blending, discursive change and authenticity in a cultural production system.' *Journal of Management Studies* 42: 1031–1055.

Hsu, G. and M.T. Hannan. 2005. 'Identities, genres and organizational forms.' *Organization Science* 16: 474–490.

Jones, C., M. Maoret, F.G. Massa, and S. Svejenova. 2012. 'Rebels with a cause: Formation, contestation, and expansion of the de novo category 'modern architecture', 1870–1975.' *Organization Science* 23: 1523–1545.

Kodeih, F. and R. Greenwood. 2014. 'Responding to institutional complexity: The role of identity.' *Organization Studies* 35: 7–39.

Lampel, J., T. Lant, and J. Shamsie. 2000. 'Balancing Act: Learning from Organizing Practices in Cultural Industries.' *Organization Science* 11: 263–269.

Perretti, F., G. Negro, and A. Lomi. 2008. 'E Pluribus Unum: Framing, Matching, and Form Emergence in U.S. Television Broadcasting, 1940–1960.' *Organization Science* 19: 533–547.

Thornton, P.H. 2004. *Markets from Culture. Institutional Logics and Organizational Decisions in Higher Education Publishing.* Stanford, CA: Stanford Business Books.

2 Comics industries

2.1 Introduction

In both the United States and Europe, comic strips and stories have appeared in books, magazines, and newspapers since the 19th century. Some European artists published comic books even before comics in other media became popular (e.g. Rodolphe Töpffer; see Filliot 2011, Groensteen and Peeters 1994).[1] In other cases, early comic books were reprints of popular comics derived from magazines and newspapers. These began to appear more regularly in the 1920s and 1930s, but the comic book industry only really began to boom in the 1940s. In Europe, this was especially the case after World War II (Kousemaker 1979, Sabin 1996, Wright 2001). In the 1940s and 1950s, comics faced censorship by governments, educational institutions, and publishers themselves in many countries, which caused a stigmatization of comics artists and audiences (Lopes 2006) that lasted until at least the 1960s.

Originally, comics were produced mostly by publishers of general magazines and newspapers. Later, specialized comics publishers entered the market. Since the beginning of the 21st century, book publishers that originally specialized in literature or other fiction genres have also entered the market with ambitious comics targeting adult audiences, called graphic novels.

Another important evolution in comics in the 20th century was the evolution from a 'dependent' into an independent medium. In the early decades of the 20th century, comics often filled just a small space or a few pages in general magazines and newspapers. Later, specialized comics magazines appeared, and finally comics were published in books and albums.[2] The album format became the dominant format for comics in Europe, especially from the 1980s onwards. Since the rise of the graphic novel, the alternative size is that of a book.

DOI: 10.4324/9781003328179-2

Comics have evolved during the last decades due to both strategic choices of publishers and artistic innovations—developments that have drastically changed the position of publishers and comics artists. Artists—especially ambitious artists—played a very important role in the evolution of comics, with avant-garde and underground artists seeking more autonomy in their creations by starting their own independent publishing companies in the 1960s and 1970s. Institutions such as critics, media, societies of fans, and governments have also played roles in the recognition of comics, often in their reactions to artistic initiatives.

The rise of underground comics in the 1960s cannot be viewed separately from societal developments such as the rise of youth culture and counterculture movements. The more recent phenomenon of the graphic novel is related to a further democratization of culture, and to a general shift from a 'word' culture to an image-driven one. Demographic variables have also played a role, such as the ageing of generations born in the 1940s, 1950s, and early 1960s. These generations of adults who read comics as children have brought the producers (publishers and artists) of new comics and the audiences that participated, whether actively or passively, in the evolution of the comic book. In Europe (or at least in France, Belgium, and the Netherlands), this participation even extends to Ministers of Culture, who read comics as children and later, when they reached positions of influence, developed policies to support institutions for comics (e.g. comics museums, awards for artists, and comics festivals) and introduced grants for comics artists.

2.2 Comics in France, Belgium, and the Netherlands[3]

2.2.1 Historical developments

The recognition of comics as a form of art or cultural heritage first appeared in France in the 1980s, when support for comics by the French government led to a certain level of institutionalization of comics. This was particularly apparent in the yearly comics festival in Angoulême, which, thanks to subsidies from the Ministry of Culture and the local government, grew to be the largest and most important comics festival in Europe. The French Ministry of Culture and other governmental institutions also supported exhibitions dedicated to comics in French general museums, a specialized comics museum, and a training college for young comics artists. These actions certainly contributed to the image of France as an important producer and

innovator of comics. Indirectly, they also led to increased support for comics from governments in (among others) Belgium and the Netherlands, which developed their own measures to support local comics, comics artists, and publishers (Audi 2021; Van Baelen 2021; Pollmann 2021). However, the comics-supporting policies not only started earlier in France but also were more fundamental and structural than in the other two countries, whose corresponding measures were more modest and often only temporary. In France, the support from governmental institutions further stimulated the legitimacy of *'la bande dessinée'*—the comic strip—as a typical French form of art (Lesage 2023).

Within Europe, Belgium and France played especially crucial roles in the development of comics. The Franco-Belgian comics surrounding characters like *Tintin, Asterix*, and *Lucky Luke* have become internationally bestselling evergreens, and, with the Flemish *Suske & Wiske*, form the top four bestselling European comic albums.[4] They are evergreens indeed, because these series, which launched more than 60 years ago, remain in print and popular. In the middle of the last century, the Belgian 'schools' of artists who filled the pages of the comics magazines *Spirou* (the home of *Lucky Luke*, among many others) and *Tintin* were very influential, leading the French-speaking part of Belgium (Wallonia and Brussels) to become the centre of the European comics world. Because Belgium is bilingual, the magazines and the albums derived from them were available not only in French but also in Dutch-language editions. They were also exported to other French- or Dutch-speaking countries, such as France, Switzerland, and the Netherlands, and gradually became popular elsewhere as well. The creator of *Tintin*, Hergé, is considered the godfather of 20th-century European comics. The publishers Dupuis (*Spirou*), Lombard (*Tintin* magazine and albums, except those of Hergé's character *Tintin* himself), and Casterman (Hergé's albums, among others *Tintin*) held leading positions in the comics niche in the middle of the last century.

Flanders, the Dutch-speaking part of Belgium, also has a high production of originally Dutch-language comics, although, typically, Flemish family comics are only popular in their home market. Many of these were originally pre-published in newspapers. The best-known Flemish artist was Willy Vandersteen, who, with his Vandersteen studios, had an enormously high production rate of comics series. The most popular of these is the long-running series *Suske & Wiske (Bob et Bobette)*, which was exported to a number of countries but today is mainly known in the Netherlands and Belgium. *Suske & Wiske* is among the bestselling comics titles in Europe (see previous endnote). Another popular series from the Vandersteen studios was *Bessy*, which

sold very well in Germany.[5] Most of the Vandersteen studios series were published in Belgium by Standaard Uitgeverij. This publisher acquired other, smaller, publishers and also obtained the rights to many other popular Flemish comics. After these acquisitions, Standaard held an almost monopolistic position in the niche of originally Flemish comics. Although all Flemish series are published in Dutch, they are rarely sold in the Netherlands—with the clear exception of *Suske & Wiske*, which has become even more popular there than in Flanders.

Beginning in the 1960s with the magazine *Pilote* (birthplace of *Asterix*, published by Dargaud), France gradually took over Belgium's role as the centre of the comics world, becoming the largest producer of comics in Europe by the end of the 20th century. In the 1970s, new specialized French publishers introduced innovative comics for older audiences, in which the role of the artist became more important than in the Belgian comics. The collaboration and competition between Belgian and French publishers and artists intensified, leading to adaptations by Belgian publishers of the French innovations. France and Belgium became the main European comics export centres. The international success of French-language comic albums is remarkable itself, as it shows that the markets of (traditionally) popular culture are not by definition dominated by Anglo-Saxon countries, as is the case with motion pictures and pop music.

In the Netherlands, the situation is very different. A limited number of comics of Dutch origin are successful nowadays, but hardly any of these are known abroad. In the past, the Netherlands had a much stronger position on the European comics market. After 1945, and until the early 1950s, Toonder Studios, which was started during World War II by the most influential Dutch comics artist, Marten Toonder, were important exporters of Dutch comics. Toonder Studios' comics series were published in newspapers and magazines in many European countries, including Belgium, France, the UK, Germany, and Scandinavian countries. However, this short-lived prosperity disappeared in the course of the 1950s, when Dutch comics lost their appeal to other nations. This was mainly caused by the format that Toonder Studios used for their exported comics, with divided text and images instead of balloons inside the images. The balloon comic, made popular in Europe by, among others, Hergé and his creation Tintin, became the international standard format for comics after the war, also due to imported comics from the US and the UK that used this style. Since Toonder Studios did not adapt their format, they soon lost the competition with balloon comics. Only in the Dutch home market did the

Toonder comics survive, mainly because of the exceptional role of Marten Toonder himself. Toonder's multilayered stories, focusing on main characters Tom Poes and Ollie B. Bommel, which were pre-published in newspapers, had a decidedly literary character, and paperbacks with these characters' stories were published by Dutch literary publisher De Bezige Bij as early as the 1960s, years before graphic novels were published by literary publishers in other countries. The paperbacks became bestsellers, in part because of the presentation format that the publisher introduced: the images were reproduced on a much smaller scale than in the original newspaper comics, so that the text underneath the images got more attention, granting the books greater legitimacy to come from a publisher mainly known for its literary novels and poetry (De Vries 2010). This format also increased the attention towards Toonder's specific use of the Dutch language, leading to the enormous popularity of expressions used by his characters. A number of these even ended up in new editions of the most distinguished Dutch dictionary (the *Van Dale*, named after its publisher).

Whereas, until the early 1960s, the production of originally Dutch comics exceeded the supply of translated and imported comics, this situation has since reversed, and today the number of imported and translated comics in the Netherlands is far higher than that of exported comics. Of all the approximately 7,500 Dutch-language comic albums that appeared on the Dutch market in the period 1998–2008, only 13% were of Dutch origin. A comparable percentage were from Flanders (and thus also originally in Dutch), but the majority were translated, mostly from French.[6] In comparison, of all Dutch books published in the same period, 75% were originally Dutch (Heilbron 1995). Many Belgian and French comics have been translated and published in Dutch comics magazines, of which the most successful were owned by VNU publishers. VNU was the result of a merger in 1965 between the largest Dutch magazine publishers. Some of the innovative comics trends in France have also been introduced in the Netherlands, albeit on a smaller scale than might be expected when considering only the demographic differences between the two countries.

Sales of comic albums compared

As the above discussion makes clear, the position of comic albums and their publishers varies by country, and many developments have altered these positions in recent decades. The differing histories of comics in

different countries are also reflected in their sales. Unfortunately, comparable sales data on a national aggregation level from all three countries are not available. Unlike in the music and movie industries, there is no international comics organization that collects such data. Thus, the information can only be derived from market research organizations that work on behalf of general publishing industries, and these only mention sales of comic albums as a separate category if they are high enough to warrant doing so. Moreover, in the few years that comics sales figures have been collected for the Netherlands, Belgium, and France, differences in methods of collecting data make it difficult to make a valid comparison that covers a longer period. However, Table 2.1. offers an indication using data for the year 2006—one of the few years, and the most recent one, for which data could be found about each of the three countries.

The differences between the Netherlands and the other two countries are striking. It is clear that comics are far more popular in France and Belgium than in the Netherlands. In Belgium, Wallonia is more comics-oriented than Flanders. In France, *les bandes dessinées* were 'hot' in the first decade of the 21st century, being among the fastest-growing book genres, with more than 40 million albums sold annually (GfK France, 2007 and 2008). There is an enormous variety in supply, and comics receive significant media exposure. Comics are also popular in both parts of Belgium—certainly more so than in the Netherlands, where they have become no more than a small niche.

Table 2.1 Comic album sales in 2006; France, Belgium, and the Netherlands compared

	France	Wallonia	Flanders	Belgium in total (Wallonia and Flanders)	The Netherlands
Sales of comic albums (x 1000 €)	383,000	38,727	11,808	50,535	3,981
Comic albums sales per inhabitant (in €)	6.08	9.16	1.88	4.81	0.24
Share of comic albums in total book sales (%)	14.3%	15.3%	9.5%	13.4%	0.8%

Sources: France: GfK France (2008); Wallonia: Ministère de la Communauté française de Belgique (2008); Flanders: Boek.be (2008); the Netherlands: GfK The Netherlands (2008).

2.2.2 Comics sales after 2006

In the years after 2006, and particularly after the worldwide economic crisis that started in 2008, comics sales in the Netherlands became too modest to be included as a separate category within the total statistics of book sales, making a robust comparison between the countries in later years almost impossible. This situation again illustrates the limited popularity of comics in the Netherlands.

Due to the fast development of the internet since 2000, online games, social media, and streaming networks (e.g. Netflix, Prime, Disney+) have become more popular than comics among the younger generations, as a source of entertainment. Nonetheless, comics have remained popular in Belgium and France. Following the initial phase of the COVID-19 pandemic, in 2021 the total number of books sold in France increased by 12.5% over the year before, but the number of comics sold increased by 34%. Comics sales in France in 2021 reached 889 million euros, representing 85.1 million copies sold. Comics have become the bestselling book genre after literature in France, with a market share of 25%. In 2021, a new *Asterix* album appeared, and was, as previous *Asterix* albums had been, the bestselling book in France that year, with an estimated 2.4 million copies sold. The market share of comics increased in Wallonia as well, with 5.5 million comics albums sold in 2021 (Stripspeciaalzaak 2022). In Wallonia, comics are now the bestselling book genre. Comic books are also among the most popular book genres in Flanders; however, as with the Netherlands, specific numbers are not available due to a lack of recent data.

In France and Wallonia, an enormous shift has taken place in comics sales, from mainly originally French-language comics to imported comics from Japan and the US. In particular, the originally Japanese manga have become very popular and, among young readers, have outcompeted sales of originally French-language comics albums. At first, the French manga translations became bestsellers, but the sales of English editions of manga titles gradually increased as well. The same phenomenon can be seen in Flanders and in the Netherlands, where the English translations have outcompeted the Dutch-language versions of manga. The French publishers Glénat and Kana (the latter an imprint of Dargaud), who introduced manga to the European market, have even completely stopped offering Dutch translations (also see the Glénat case presented later in this book).

The popularity of social media has led to people in many Western countries gaining a better mastery of the English language at an earlier age than in the past. This phenomenon coincides with the growing popularity of English-language fiction books in general among young readers. At the same time, streaming television platforms such as

12 Comics industries

Netflix broadcast many anime series, which are often based on manga series. Especially during the COVID-19 lockdown periods, these series became very popular among young adults.

Digitalization (among others in the form of e-books) has had a growing impact on the sales of many book genres but a lesser effect on the sales of comic albums. Webcomics and comics produced for smartphones are relatively new additions to the supply of printed comics, and according to Audi (2021), French-language comic album publishers get less than 1% of their revenues from digital comic books.

2.2.3 Readers of comics

In addition to sales information, other data that make the cross-border comparison more complete are related to demand and supply—that is, the number of readers of comics in each country and the yearly production of comic albums.

In each of the countries (and regions) studied, available data from the early 2000s provide insights into the interest in comics among readers. These data come from national enquiries about cultural participation and are representative of the whole population. The surveys include hundreds of topics, of which respondents' interest in different types of books is only one. Respondents were asked whether they had actually read any comic books in the twelve months before the enquiry (six months for Flanders). Table 2.2. gives an overview of the percentages of respondents that answered yes.

These data show the same pattern as the sales figures: comic albums are most popular in Wallonia, followed by France, Flanders, and finally the Netherlands.[7] The relative interest in comics in France is twice as high

Table 2.2 Readers of comic albums

Country	Readers of comic albums, in percentages of total population*	Estimate of absolute numbers of comics readers	Year of enquiry
France	29%	16 million	2008
Wallonia	36%	1.3 million	2007
Flanders	22%	1.2 million	2009
The Netherlands	14%	2 million	2005

Sources: the Netherlands: TBO (2005); Flanders: Lievens and Waege (2011); Wallonia: Ministère de la Communauté française (2009); France: Ministère de la Culture et de la Communication (2011).

* Percentage of respondents who have read at least one comic album in the twelve months previous to the enquiry (six months for Flanders).

as in the Netherlands. If we translate the percentages to absolute numbers of readers in each country, we see that there are eight times as many readers of comic albums in France (16 million) as in the Netherlands (2 million), although there are less than four times as many people in France than in the Netherlands. In absolute numbers, Belgium (Flanders and Wallonia together), with 10 million inhabitants at the time of the survey, has more comics readers than the Netherlands, with a population of 16 million in the same period. Within Belgium, Wallonia (4 million inhabitants) has more comics readers than Flanders (6 million inhabitants).

The above numbers provide only the most recent findings for which information about each of the countries/regions was available, but in each, at least one earlier survey had asked the same question about reading comic albums. The years in which these enquiries took place differ, but a comparison nevertheless offers some insight into changes in the interest in comic albums in each country/region. Figure 2.1 gives an overview.

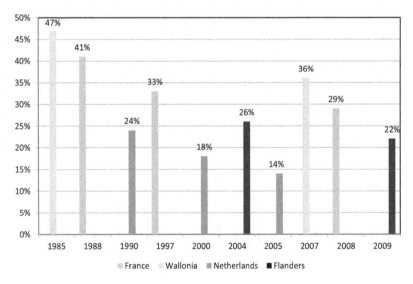

Figure 2.1 Changes in reading of comic albums, in percentages of total population
Explanatory notes: Percentages of respondents who read comic albums in the twelve months prior to the enquiry (six months for Flanders).
On the x-axis only the years in which data for at least one country were available are shown.
Sources: National enquiries into cultural participation (see Table 2.2; France: surveys from 1988, 1997, and 2008; Wallonia: 1985 and 2007; Netherlands: 1990, 2000, and 2005; Flanders: 2004 and 2009).

14 Comics industries

The general trend is clear: the percentages of comic album readers have decreased in each country/region. In the 1980s, these percentages were very high in Wallonia (1985: 47%) and France (1988: 41%) in comparison with later years. Meanwhile, the differences between the countries have remained similar. In the Netherlands, the decrease was relatively stronger than in the other countries; whereas in 1990 almost one out of every four Dutch respondents (24%) had read at least one comic book in the previous year, this number decreased to almost one in seven Dutch people in 2005 (14%).

2.2.4 Production of comic albums

To conclude the comparisons, we shall use data regarding the production of comic albums. These data also have a limitation: in the Dutch and Flemish sources, all Dutch-language comic albums are considered together, and the same is true in the French and Walloon sources for the French albums.

Figure 2.2 shows the supply of album titles in the period 1985–2009. It becomes clear that the supply of French-language albums dramatically increased, especially from the end of the 1990s onwards. Whereas, before the 1990s, the supplies of French- and Dutch-language comics were more or less comparable, in the early 2000s that balance was lost. In 2008, the last year included, more than 3,500 French-language comic albums were produced, compared with only 1,000 Dutch-language comic albums.

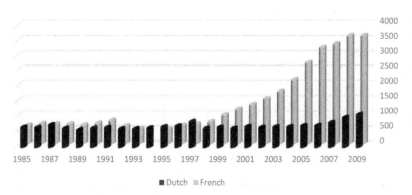

Figure 2.2 Title supply of Dutch and French language comic albums in the period 1985–2009
Sources: Dutch language: 1985–2002: SDCN-database; 2003–2004: De Officieuze Strippagina; 2005–2009: Stripspeciaal-Zaak. French language: 1985–1996: Groensteen (1987 and 1993), Miller (2007); 1997–2005: Ciment et al. (2009); 2006–2008: Ratier (2007, 2008, 2009).

As the findings regarding numbers of readers show (see Figure 2.1), this growth in production is not caused by an increase of readers on the francophone market. On the contrary, the percentages of readers in Wallonia and France have dropped. This indicates that there is an overproduction on the francophone market.[8]

All of these differences, which of course have consequences for publishers, make it interesting to continue examining these neighbouring countries in the next chapters of this book.

Notes

1 According to, among others, the French and Belgian comics experts Groensteen and Peeters (1994) and Lefèvre and Dierick (1998), Töpffer is internationally regarded as the creator of the first modern comics.
2 'Comic album', or simply 'album', is the common name for comic books with complete stories in France, Belgium, and the Netherlands.
3 For a more detailed overview of the developments in the French and Belgian comics industry and the roles of the changes in publication formats and in audiences for comics, refer to Beaty (2007) and Lesage (2018, 2019, and 2023).
4 Top four of Europe's bestselling comic album series in the early 2000s: (1) *Asterix*: French, by Goscinny and Uderzo, and since 1977 by Uderzo, started in 1959, published by Dargaud, and since 1998 by Albert-René/Hachette, 31 album titles, 320 million albums sold by 2004 (*Capital* 2004: 52); (2) *Lucky Luke*: Belgian, by Morris and others, started in 1947, published by Dupuis, Dargaud, and since 1991 by Lucky Comics, 72 album titles, 200 million albums sold by 2004 (*Capital* 2004: 54); (3) *Tintin*: Belgian, by Hergé, started in 1929, published by Casterman since 1934, 24 album titles, 193 million albums sold by 2004 (*Capital* 2004: 55); (4) *Suske en Wiske (Bob and Bobette)*: Belgian, by Vandersteen and Vandersteen Studios, started in 1945, published by Standaard Uitgeverij, 185 album titles in 1997 (Matla 1998), 128 million albums sold by 1997 (Lodewyckx 1998: 56; estimated sales by 2004: 130 million albums). By 2004, no other European album series had sold more than 100 million albums in total. *Tintin* is the only one of these four series that was not continued after the death of its creator (Hergé died in 1983). The other series were continued after their creators' deaths by a co-creator (*Asterix*: Uderzo, after Goscinny died) or by new generations of artists (*Suske and Wiske, Lucky Luke, Asterix*). After 2004, *Asterix* has been the only comic album series from the top four that has continued to sell as well as in earlier decades, at least in France. Each new *Asterix* title is among the bestselling books of that year in France.
5 *Bessy* was published as a magazine in Germany, and a selected number of stories were published as albums in Belgium. The accumulated sales of albums (15 million) and magazines (135 million) amount to 150 million copies (Lodewyckx 1998: 56).
6 Source: author's database.
7 Appendix I analyses the extent to which religious denomination and the religious history of a country can contribute to explaining these striking

differences. Attention is also given to other demographic variables that are relevant for the readership of comics.
8 This is confirmed by the French study *L'état de la bande dessinée* (Ciment et al. 2009), which focuses on the consequences of the overproduction.

Bibliography

Audi, C.G. 2021. *Belgian Bande dessinée(s): Industry, Policy & Legitimacy.* Master's Thesis, Erasmus University Rotterdam.
Beaty, B. 2007. *Unpopular Culture: Transforming the European Comic Book in the 1990s.* Toronto: University of Toronto Press.
Boek.be (2008). http://www.boek.be/.
Capital. 2004. « Les stars de la BD au pays du business – Dossier international », Nr. 148.
Ciment, G. et al. 2009. *L'état de la Bande bande dessinée. Vive la crise?* Brussels: Les impressions nouvelles/CIBDI.
De Officieuze Strippagina. http://www.strippagina.nl/.
De Vries, R. 2010. 'Vernieuwing in de Nederlandse strip: stigma's en etiketten'. In: Z. Hrnčiřová, K. Mercks, J. Pekelder, E. Krol, and J. Ultzen (eds.), *Praagse Perspectieven 6*, 131–152. Prague: University Press.
Filliott, C. 2011. *La bande dessinée au siècle de Rodolphe Töpffer: catalogue commenté des albums et feuilletons publiés à Paris et à Genève, de 1835 à 1905.* Thèse de doctorat Lettres modernes, Toulouse 2.
GfK Retail and Technology/Stichting Marktonderzoek Boekenvak. 2009. *Strips 360-366-2006 2007 2008-weekbasis.* 'GfK Retail and Technology/Stichting Marktonderzoek Boekenvak' (Excel file; data used with permission of GfK Retail and Technology/Stichting Marktonderzoek Boekenvak).
Groensteen, T. 1987. 'La production en chiffres'. In: S. Barets and T. Groensteen (eds.), *L'Année de la bande dessinée 1986–1987*, 12–15. Grenoble: Glénat.
Groensteen, T. 1993. 'Le marché de la bande dessinée en 1992'. In T. Groensteen (ed.), *Toute la bande dessinée 92*, 10–16. Paris: Dargaud.
Groensteen, T., and B. Peeters (eds.) 1994. *Rodolphe Töpffer. L'Invention de la bande dessinée.* Paris: Hermann.
Heilbron, J. 1995. 'Nederlandse vertalingen wereldwijd. Kleine landen en culturele mondialisering'. In J. Heilbron, W. de Nooy, W. Tichelaar (eds.), *Waarin een klein land. Nederlandse cultuur in internationaal verband*, 206–252. Amsterdam: Prometheus.
Kousemaker, K., and E. Kousemaker. 1979. *Wordt vervolgd. Stripleksikon der Lage Landen.* Utrecht: Het Spectrum.
Lefèvre, P., and C. Dierick (eds.) 1998. *Forging a New Medium. The Comic Strip in the Nineteenth Century.* Brussels: VUB University Press.
Lesage, S. (2018). *Publier la bande dessinée. Les éditeurs franco-belges et l'album, 1950–1990.* Villeurbanne: Presses de l'Ensibb.
Lesage, S. (2019). *L'Effet livre. Métamorphoses de la bande dessinée.* Tours: Presses universitaires François-Rabelais.

Lesage, S. (2023). *Ninth Art. Bandes dessinée, Books and the Gentrification of Mass Culture, 1964–1975*. Cham: Palgrave MacMillan/Springer Nature Switzerland AG.

Lievens, J. and H. Waege. 2011. *Participatie in Vlaanderen. Basisgegevens van de Participatiesurvey 2009*. Leuven/Den Haag: Acco.

Lodewyckx, J. 1998. 'De klinkende kassa'. In M. Schifferstein (ed.), *Stripjaar 1997*, 55–62. Amsterdam: Sherpa i.s.m. Stichting Beeldverhaal Nederland.

Lopes, P. 2006. 'Culture and Stigma: Popular Culture and the Case of Comic Books.' *Sociological Forum* 21:387–414.

Matla, H. 1998. *De Stripkatalogus – De Negende Dimensie*. Den Haag: Panda.

Miller, A. 2007. *Reading Bande Dessinée. Critical Approaches to French-language Comic Strip*. Bristol, UK/Chicago, USA: Intellect.

Ministère de la Communauté française, Secrétariat Géneral, Direction de la Recherche. 2009. 'Une radiographie des loisirs culturels'. *Faits & Gestes* No 30.

Ministère de la Culture et de la Communication, Département des Etudes, de la Prospective et des Statistiques. 2011. *Les pratiques culturelles des Français a l'ère numérique*. http://www.pratiquesculturelles.culture.gouv.fr/.

Observatoire des politiques culturelles–OPC. 2007. *Enquête relative aux pratiques culturelles, aux. loisirs des 16 ans et plus résidant en FW-B de 2007, données récoltées par IPSOS*.

Pollmann, J. 2021. 'Status quo in Nederland. Tour d'horizon bij de noorderburen.' *Stripgids* nr 10: 34–41.

Ratier, G. 2007. '2006: L'année de la maturation'. *ACBD*. http://www.acbd.fr/bilan/les-bilans-de-lacbd.html.

Ratier, G. 2008. '2007: Diversité en vitalité.' *ACBD*. http://www.acbd.fr/bilan/les-bilans-de-lacbd.html.

Ratier, G. 2009. '2008: « Recherche nouveaux marchés… Désespérement! »'. *ACBD*. http://www.acbd.fr/bilan/les-bilans-de-lacbd.html.

Sabin, R. 1996. *Comics, Comix and Graphic Novels: A History of Comic Art*. London: Phaidon Press.

SDCN. 2005. *SDCN-database*. Amsterdam: Strip Documentatie Centrum Nederland (Excel file for internal use by SDCN, data used with permission of SDCN; SDCN is a department of the University Library at the University of Amsterdam).

Stripspeciaal-Zaak. http://www.stripspeciaalzaak.be/.

Stripspeciaalzaak. 2022. 'Boeken- en stripverkoop steeg in 2021 in België, Nederland en Frankrijk'. February 1. https://www.stripspeciaalzaak.be/stripnieuws/boeken-en-stripverkoop-steeg-2021-belgie-nederland-en-frankrijk.

Steunpunt voor Beleidsrelevant Onderzoek Cultuur. 2007. *Participatiesurvey 2003–2004*.

TBO. 2005. *Sociaal en Cultureel Planbureau (01/08/2005–14/11/2005) Tijdsbestedingsonderzoek 2005 – TBO 2005* (SPSS files). Data deposited at DANS (Data Archiving and Networked Services). Identifier: urn:nbn:nl:ui:13-v64-rd7.

Van Baelen, C. 2021. 'Stripbeleid van het Vlaams Fonds voor de Letteren in het eerste decennium. Pionieren met een "nieuwe" literaire discipline.' *Stripgids* nr. 10: 20–25.

Wright, B.W. 2001. *Comic Book Nation. The Transformation of Youth Culture in America*. Baltimore: Johns Hopkins University Press.

3 Theory[1]

3.1 Institutional logics

Institutional logics (IL) have interrelated symbolic and material dimensions. The symbolic dimension is related to meaning, whereas the material dimension is related to structures and practices (Thornton, Ocasio, and Lounsbury 2012, 10). Here, practices refer to 'a set of meaningful activities that are informed by wider cultural beliefs' (Thornton, Ocasio, and Lounsbury 2012, 128). In her study on higher education publishing conglomerates, Thornton (2004) describes how the two dimensions are related and how they are based on competing logics. She discerns two ideal types of logics: editorial logics, which pay attention to books and networking with authors; and market logics, which pay attention to the market of companies (to acquire or merge with). Thornton concludes that the logics of educational publishers have shifted from attention to their products to financial motives. With this conclusion, she confirms earlier findings by Fligstein (1990), who states that, in general, the institutional changes in large corporations shift focus from the product to sales and, finally, to a financial conception that is no longer related to a specific industry.

Thornton's support for Fligstein's findings suggests that, when organizations and their fields become bigger and older, IL naturally move from product-oriented logics to market- and finance-oriented ones. However, it is not clear whether this is always or necessarily so, or whether alternative institutional dynamics also exist. This chapter will address this open question.

Glynn and Lounsbury (2005) use concepts comparable to Thornton's in their paper about the influence of a mixture of logics within a symphony orchestra on critics in their reviews of the orchestra's concerts. They describe this effect in terms of blending aesthetic and market logics. Jones et al. (2012) show how different groups of

architects that operate within the de novo category of 'modern architecture' have conflicting logics, and how this is related to their clients.

From the research by Thornton (2004), Glynn and Lounsbury (2005), and Jones et al. (2012), it can be concluded that organizations in the same field can have a mixture of contrasting logics, and that stress on a specific type of logic depends on the situation of each organization. These studies do not determine how changes in field-level characteristics affect the logics of individual firms, but this question will be explored in the case studies in the next chapters.

The IL perspective offers a theoretical foundation for paying attention to the differences and similarities between logics. Applied to the comics industry, this perspective is especially applicable regarding logics based on aesthetic and on market values, as well as shifts in these logics over time.

IL-based research contributes to knowledge about organizational identity. However, logics and identity are not synonymous: 'while institutional logics guide *how to act* in a particular situation, the concept of identity focuses more on the question *who we are*' (Thornton, Ocasio and Lounsbury 2012, 129–130). Organizations in the same field can have 'a collective identity that is bound together by shared cognitive and normative orientations' (130).

3.2 Organizational ecology

The concept of collective identity within a field is comparable with organizational ecology's (OE's) concept of niche identity. Central to OE is the theory of legitimacy (Hannan and Freeman 1977): in the early days of an industry, the new organizational form must first develop legitimacy to stand a chance of survival. Without legitimacy, critical stakeholders such as customers and investors will not become interested in the new organizational form; consequently, it will gradually become extinct.

An important contribution of OE to IL with regard to field identity is OE's systematic differentiation of different organizational types in the same field or industry. Specifically, this chapter will focus on the distinction between 'de alio' and 'de novo' organizations. As noted earlier, de alio organizations were originally founded to function in another field, whereas de novo organizations were founded to function in the focal field.

The activities of large and well-known de alio organizations in a novel niche can be a condition for developing new product legitimacy (McKendrick and Carroll 2001), as these organizations' presence

suggests to other actors that the product is viable and that specialization in the product can offer market opportunities. Newcomers specializing in the novel product from their foundation (i.e. de novo organizations) will then subsequently start to enter the new niche.

According to Hsu and Hannan (2005), the sharpness, or visibility, of a new niche's identity depends on the share of de novo and de alio organizations in the niche. De novo organizations specialize in the new niche, whereas de alio organizations are still connected to their niche of origin. Thus, de novo organizations will only enter a niche if the niche contains enough resources for specialization; if not, then de alio organizations will continue to dominate the niche, and the niche will remain associated with these organizations and their niches of origin. Thus, the new niche will not develop into a field with an identity of its own, which can lead to a short life cycle for that niche. In summary, de alio organizations are important initially for giving a new niche legitimacy, whereas de novo organizations are needed later in order for the niche to develop an identity of its own.

What IL and OE miss separately—differences in organizational backgrounds and differences in logics, respectively—can be found when integrating their concepts. The usefulness of such integration will be explored in the findings and discussion chapters. Before that, however, the next chapter provides information on the data and methods used to obtain the findings.

Note

1 Chapters 3 to 6 of this book are partially based on an updated version of my paper 'From market logics to esthetic logics', published in *Creative Industries Journal* (De Vries, 2021).

Bibliography

De Vries, R. 2021. 'From market logics to esthetic logics: Interaction between de novos and de alios in the comics publishing industry'. *Creative Industries Journal* 14: 295–314.

Fligstein, N. 1990. *The Transformation of Corporate Control*. Cambridge, MA: Harvard University Press.

Glynn, M.A., and M. Lounsbury. 2005. 'From the critics' corner: Logic blending, discursive change and authenticity in a cultural production system.' *Journal of Management Studies* 42: 1031–1055.

Hannan, M.T., and J. Freeman. 1977. 'The population ecology of organizations.' *American Journal of Sociology* 82: 929–964.

Hsu, G., and M.T. Hannan. 2005. 'Identities, genres and organizational forms.' *Organization Science* 16: 474–490.

Jones, C., M. Maoret, F.G. Massa, and S. Svejenova. 2012. 'Rebels with a cause: Formation, contestation, and expansion of the de novo category "modern architecture", 1870–1975.' *Organization Science* 23: 1523–1545.

McKendrick, D.G., and G.R. Carroll. 2001. 'On the genesis of organizational forms: Evidence from the market for disk arrays.' *Organization Science* 12: 661–682.

Thornton, P.H. 2004. *Markets from Culture. Institutional Logics and Organizational Decisions in Higher Education Publishing*. Stanford, CA: Stanford Business Books.

Thornton, P.H., W. Ocasio, and M. Lounsbury. 2012. *The Institutional Logics Perspective: A New Approach to Culture, Structure, and Process*. Oxford: Oxford University Press.

4 Data and methods

To provide an overview of the dynamics in the French, Dutch, and Belgian comics publishing industry, available data must identify the publishers and the years in which they published comics. A dataset including this information was derived from several sources. The most important source is a database provided by the Dutch Comics Documentation Centre ('Strip Documentatie Centrum Nederland': SDCN), which is part of the library of the University of Amsterdam. SDCN, which has an extensive collection of Dutch-language comics, uses this database for bibliographical purposes. It contains comics that appeared in Belgium and the Netherlands until the year 2001, either translated into or originally in Dutch.

The *SDCN database* (2005) was checked for errors through comparison and combination, most importantly with the catalogue of the Royal Library of the Netherlands (the *KB catalogue*, Koninklijke Bibliotheek 2009–2012), which contains all official Dutch publications, and another database for Dutch-language comics collectors (Vranken, Vranken, and Matla 2001). Because the *SDCN database* appeared not to be complete after 1998, this is the most recent year included in my analysis. After the necessary changes and additions, the final database contains 24,258 albums and the titles of 653 comics magazines, with 48,987 magazine issues in total. The first Dutch-language comic book, according to definitions by comics specialists, was published in 1858.[1] In total, in the period 1858–1998, 1,184 publishers were active in Dutch-language comics production.

The original *SDCN database* does not include variables related to the de alio or de novo status of the publishers. To collect this information, publisher data were derived mainly from the digital catalogues of the national libraries of the Netherlands, Belgium (both Flanders and Wallonia), and France. If a publisher had produced books or magazines other than comics before its first comic publication, it was

DOI: 10.4324/9781003328179-4

categorized as 'de alio'. Conversely, if its first publication was a comic and many of its following publications were comics, it was categorized as 'de novo'. Applying these criteria, the database includes 822 de alio and 362 de novo publishers (69% and 31% of all comics publishers, respectively).

The descriptive statistics used in this chapter are based on the density of the de alio and de novo organizations in the population of comics publishers. The density of a population at a specific moment is expressed by the absolute number of organizations active in the niche. To avoid right censoring problems, the last year the analysis will cover is 1994.[2] Moreover, because of the rapid changes in the industry after World War II, the analysis will focus on the period 1945–1994.

To obtain detailed data at the individual organization level, case studies were considered the most suitable method. As the cases were chosen for theoretical reasons, the number of cases should be sufficient to reach theoretical saturation (Eisenhardt 1989, 545). The purpose of the case studies was to gain insight into the logics and practices of de alio and de novo publishers, as well as the interaction between both types of publishers. Comics publishers' practices are related to the work of publishers and editors; thus, relevant questions include: how do they produce and distribute comics? How do they collaborate with comics artists? Do these publishers and editors consider comics a product that must be marketed and sold like other products, in which case comics creators are merely seen as suppliers of raw material (market logics), or are the publishers intrinsically interested in the artistic dimension of comics and in the talents of their creators (aesthetic logics)? The results of these logics and practices are the comics that they publish.

The cases were chosen from among all de alio and de novo comics publishers in France, the Netherlands, and Belgium. Both categories and all three countries are represented, as well as publishers from both the French-speaking (Wallonia) and Dutch-speaking (Flanders) regions of Belgium. It appeared that studies of five publishers were sufficient to meet the conditions, as theoretical saturation was reached at that point. In line with Eisenhardt's (1989) view on theory development and case studies, polar cases were chosen 'in which the process of interest is "transparently observable"' (537).

The cases are: Dupuis; VNU ('Verenigde Nederlandse Uitgeversmaatschappijen': United Dutch Publishing Companies); Glénat; Oog & Blik (hereinafter O&B); and Bries. VNU and O&B are Dutch firms; Dupuis and Bries are from Belgium; and Glénat is from France and has a subsidiary in Brussels (Glénat Benelux) for the Belgian and

Dutch markets. Dupuis is Walloon (the native language is French, but the publisher has a very active Dutch-language division), and Bries is Flemish. In 2004, Dupuis was acquired by the French publishing conglomerate Média Participations, which already owned the influential comics publisher Dargaud. These publishers also fit with the polar extremes of the criteria: Dupuis and VNU are (relatively) large de alio generalists, Glénat is one of the biggest de novo publishers, and O&B and Bries are (very) small de novo specialists. The most extreme difference in size is between VNU and Bries: at the end of the 1990s, VNU had over 19,000 employees worldwide (Johannes and Cohen de Lara 2005, 257), whereas Bries has been a one-person firm since the start—the founder is the owner and has remained the only employee.

Dupuis and VNU were important for the development of comics magazines and albums in the 20th century in their home countries and, in the case of Dupuis, also internationally. At the end of the 20th and the beginning of the 21st century, Glénat, O&B, and Bries contributed to the diffusion of innovative authors' albums and graphic novels, and to the recognition of comics as a form of art in France, the Netherlands, and Flanders.

Data triangulation was used in the case studies. Secondary sources and primary data, derived from interviews, were collected. Secondary literature was available on each of the publishers. Among the sources were monographs about Dupuis and VNU, historical books about comics in France, Belgium, and the Netherlands, and articles from popular journals and newspapers.[3]

The *SDCN database* (2005) includes overviews of the Dutch-language comics published by the studied publishers, including year and type of publication (album or magazine) and, for albums, artist names and series titles. These overviews give a first impression of the outcomes of the publishers' practices—that is, the comics they produced. However, more detailed information on these publications was needed in order to interpret the relationship between the publishers' practices and logics; thus, this was one of the topics used for the interviews.

Contact persons from the publishers were approached with the request to participate in the research. At least one person from each organization was interviewed. All the interviewees were editors or publishers, and some had been interviewed often before for magazines and newspapers, making it possible to compare the findings from the interviews with these earlier conversations.

None of the approached candidates refused to participate. The semistructured interviews lasted from forty minutes to three hours, mainly depending on the information that was needed. They were digitally

recorded and transcribed afterwards. If part of a transcript was not clear, the interviewee was contacted again to clarify the answers, though this was only necessary in a few cases.

After the data were collected, within-case analyses of the five publishers were conducted, as well as a cross-case analysis (Eisenhardt 1989) in which the de alio and de novo organizations from the three countries were compared. The next section presents the findings of the research and includes literature that helps to explain the findings and their implications.

Notes

1 In 1858, the album *De Reizen en Avonturen van Mijnheer Prikkebeen* appeared—a translation from French of the album *Monsieur Cryptogame* by the Swiss artist Rodolphe Töpffer. According to the Dutch comics expert Matla (1998), this was the first Dutch-language comics album. Also see endnote 1 in Chapter 2 regarding Töpffer's role in the development of modern comics.
2 Some publishers produce albums only occasionally—for example, three albums in year t, no albums at all in years t+1 and t+2, and then ten albums in year t+3. However, it can be expected that comics publishing knowledge will not quickly disappear if there is a period in which no comics albums are made. For this reason, it was decided that the maximum length of non-activity acceptable for inclusion in the density figures could be relatively long, at five years. Publishers who do not produce an album during a period longer than five years are considered to have left the comics niche. In the most recent years covered in the database, it becomes more complicated to calculate density because of right censoring problems. Inactive publishers in this period might have exited the niche, but this cannot be calculated because the data are only reliable until the year 1998. For that reason, the last year that the quantitative part of the analysis will cover is 1994.
3 See the references at the end of Chapter 5. More detailed information about the case organizations can be found in De Vries (2012).

Bibliography

De Vries, R. 2012. *Comics and Co-evolutions. A Study of the Dynamics in the Niche of Comics publishers in the Low Countries.* PhD diss., University of Groningen.

Eisenhardt, K.M. 1989. 'Building theories from case study research.' *Academy of Management Review 14*: 532–550.

Koninklijke Bibliotheek. 2009–2012. *KB-catalogue.* Retrieved from http://opc4.kb.nl/?LNG=NE (Online catalogue of the Royal Library of The Netherlands, accessed in the period 2009–2012).

Matla, H. 1998. *De Stripkatalogus – De Negende Dimensie.* Den Haag: Panda.

SDCN. 2005. *SDCN-database*. Amsterdam: Strip Documentatie Centrum Nederland. (Excel file for internal use by SDCN, data used with permission of SDCN; SDCN is a department of the University Library at the University of Amsterdam).

Vranken, P., L. Vranken, and H. Matla. 2001. *The Collector's File*. N.p. (Belgium): Amber-VM (CD-ROM).

5 Findings

5.1 Introduction

The findings presented here show, first, how the de alio/de novo ratios of Dutch-language comics publishers changed in the period 1945–1994.[1] Together with the historical overview already given, this information serves as a context for the case studies and the cross-case analysis at the end of this chapter.

De alio publishers far outnumbered de novo publishers in the period 1945–1970, as Figures 5.1 and 5.2 show. In the 1970s, this began to change, and by the middle of the 1980s they were almost in equilibrium. Beginning in 1988, de novo publishers were the new majority. The proportion continued to shift to the advantage of de novo publishers, and in the most recent years in the database (1990–1994) they constituted 64% of the population, on average.[2]

5.2 Case studies

5.2.1 Dupuis (Belgian de alio, Walloon)

Dupuis started as a Walloon family-owned firm which published magazines for a general audience, beginning in the 1920s. In 1938, Dupuis began publishing the comics magazine *Spirou* in two languages (French and Dutch) to reach audiences in Belgium, France, and the Netherlands.[3] Having started as a general publisher, Dupuis gradually became one of Belgium's most productive comics publishers. Its bilingual publications enabled Dupuis to reach an enormous market, and by the early 1960s the weekly circulation for the French and Belgian editions of *Spirou* was almost 300,000 copies.

After World War II, Dupuis developed specific practices for publishing comics albums. These had a steady formula: a predetermined

DOI: 10.4324/9781003328179-5

Findings 29

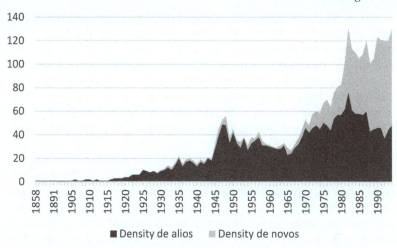

Figure 5.1 De alio and de novo publishers of comics albums (1858–1994)
Source: Author's database, based on SDCN (2005).

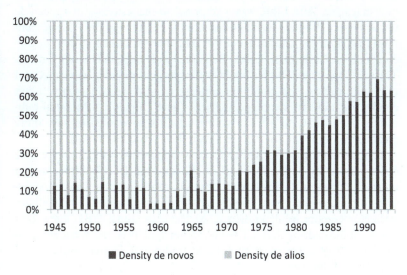

Figure 5.2 Proportions of de alio and de novo publishers of comics albums (1945–1994)
Source: Author's database, based on SDCN (2005).

length of 48 pages, with content based on stories that had previously been published in *Spirou*. The constraint regarding the number of pages came from necessity: paper was scarce in the years after the war, and the 48-page format enabled Dupuis to make the most efficient use of standard sizes for industrial paper. This formula gave Dupuis a recognizable image as a comics magazine and album publisher. The album series from *Spirou* were reprinted repeatedly over the decades. These formula-based practices were soon copied by other comics publishers, including the Dutch VNU.

In 1985, the division of Dupuis that was responsible for the comics magazines and albums was acquired by Groupe Bruxelles Lambert (GBL) and the French publisher Hachette. At that time, *Spirou* magazine had already lost many of its readers and had become less profitable than the album series. Nevertheless, all Dupuis' comics albums at that time were still originally from the magazine, and none were targeted to the new adult comics audiences.

In 1988, Dupuis' new comics editor, the comics albums scenarist Jean van Hamme, was allowed to launch a new album series, Aire Libre, based on the author's albums that had become popular. The albums in this series contained complete stories that had not been previously published in a magazine. Aire Libre was a response to the successes of French de novo album publishers such as Glénat and Les Humanoïdes Associés, but it was also Dupuis' answer to comparable series published by their de alio competitors Casterman, from Belgium, and Dargaud, from France. Through this series, Dupuis could realize its goal of being associated not only with *Spirou* and children's comics but also with innovative adult comics. As another advantage, the series gave Dupuis a substantial publishing opportunity to offer to young artists, who wanted to have more creative freedom with their comics than their predecessors had.

The market logics that led to Dupuis' acquisition by GBL were thus accompanied by aesthetic logics at the editorial level: editors, with a network of young (French and Belgian) comics artists, were empowered to choose and guide talents for the production of the new album series for a more adult audience. At the same time, GBL knew that many albums series derived from *Spirou* had become evergreens, so they also kept them in print for the traditional Dupuis audience of children and families.

In 2004, GBL sold Dupuis to Média Participations (MP), which became Europe's largest comics publisher following this acquisition. MP is headquartered in Paris and is also home to the other large Belgian and French comics publishers Lombard and Dargaud, which were acquired earlier.

In 2006, the market logics that prevailed in MP's top management led to a conflict with the Dupuis artists and editors when MP announced the firing of Dupuis' popular main comics editor. The artists wrote a joint protest letter to the CEO in which they demanded more autonomy for their editors at Dupuis. After this action, MP's CEO guaranteed Dupuis' autonomy, but popular editors and artists had already lost faith in the publisher and left despite MP's promises. It took years before the situation stabilized again.

5.2.2 VNU (Dutch de alio)

VNU was the result of a merger between several magazine publishers in 1964. VNU dominated the Dutch magazine market for a general audience, and for a long time it was also by far the Netherlands' largest producer of comics. Some of the publishers that later merged into VNU had produced comics since the 1920s as a small but constant part of their publishing portfolios.

In the 1960s, comics gradually gained a more prominent place within VNU, as reflected by the amount of time that editors were allowed to spend on them. VNU imported knowledge of the comics market from Belgium by hiring an originally Dutch former Dupuis editor. His first initiatives to publish comics albums on a regular basis were met with distrust from VNU managers and distributors; they were not used to albums, which were more closely related to books than to the magazines with which they were familiar.

In the 1970s, separate functions were created for the VNU comics albums and comics magazines departments, including editing, marketing, merchandising, and licensing, and VNU's comics-related practices became more professionalized. Separate comics divisions (Oberon, followed by Big Balloon) were launched, whose practices were comparable to those of Belgian and French de alio comics publishers that had previously launched specialized comics divisions.

In the same period, the subscriptions to comics magazines, which in the 1960s had reached the hundreds of thousands for the most popular titles, started to decrease strongly, leading to a greater focus on albums. However, VNU's magazine distributors faced difficulties in distributing these albums. Specialized comics shops that had spread throughout the Netherlands in the 1970s were a perfect distribution channel for the many albums from specialized de novo comics publishers, but the audience of these shops (adolescent and adult comics fans) was too small and fragmented for a big publisher like VNU. Many new album

series found only a limited audience; these were products for a niche market instead of the mass market that comics magazines addressed.

Nevertheless, in the 1980s and 1990s, VNU's comics division Big Balloon tried to reach the comics shops audience with many album series. Among the translated albums were innovative and artistic author albums, licensed from French de novo comics publishers such as Glénat and Les Humanoïdes Associés, which had not been published in Dutch before.

The young comics albums editors at VNU in the 1970s and 1980s considered the commercial potential of a new series before publishing it, but they also maintained a genuine interest in comics and their creators, as they had been comics fans and collectors before being recruited by VNU. Thus, whereas their predecessors' practices were based purely on market logics, those of the new generation of editors were based on a mixture of market and aesthetic logics.

These logics in the editorial departments contrasted with those of the VNU managers, which increasingly focused on the market of companies to acquire or merge with. By 2001, after more acquisitions, VNU had become an enormous company for which the Dutch magazine and comics albums market was too fragmented and unpredictable. Thus, VNU sold not only the titles of their remaining comics magazines but *all* their magazines for a general audience, to the Finnish publisher Sanoma. Big Balloon became an independent comics publisher that still exists today, although it only publishes sporadically (mainly comics adaptations of new Disney movies).

5.2.3 Glénat (French de novo)

Glénat was founded in 1969 by its eponym, Jacques Glénat. Glénat was a fan of comics, and at the young age of 17 he had published the home-made comics fanzine *Schtroumpf* (the original name for Peyo's comic known as *The Smurfs* in the Netherlands). A few years later, he began to publish comics albums more professionally.

Beginning in 1975, Glénat also published the comics magazine *Circus*, which targeted adolescents and adults and contained both new and reprinted comics from France and other countries. In 1985, he published a second comics magazine, *Veçu*, that especially focused on comics with a link to French history. Several of these comics were republished afterwards in album series. Glénat also released a sequel to *Schtroumpf*—the professional comics magazine *Les Cahiers de la BD*.

During the 1980s, the number of comics album series that Glénat published increased dramatically, and some were huge bestsellers.

Soon, Glénat ranked second in France in the number of comics it published, surpassed only by the much bigger publisher Dargaud. Nevertheless, Glénat was able to stay independent as a publisher.

In 1985, Glénat started its own subsidiary situated in Brussels, Glénat Benelux, intended for distribution in Belgium as well as production and distribution of Dutch-language versions of a selection of Glénat's French-language comics. The decision to start a subsidiary was prompted by well-known Belgian comics artists Glénat contacted in France, who insisted they would only allow their work to be published by Glénat if a Dutch translation (for the Flemish part of Belgium) would also be made available. Later, other subsidiaries were added as well, for example in Switzerland, Spain, and Canada. With these subsidiaries, Glénat was unusual in the world of French comics publishers, who usually licensed their comics to publishers in other countries.

Paul Herman, the literary director for Glénat Benelux in Brussels, selected albums and series that would be most suitable for the Flemish and Dutch markets. Glénat Benelux only published about 10% of the comics that had previously appeared in French, while they also licensed many other Glénat series to Flemish and Dutch publishers such as Daedalus, Talent, and Arboris. Herman also initiated series for the French-language market of Glénat. In the late 1980s, Glénat also started its own comic book shops in France, Switzerland, and Belgium.

In the 1990s, Glénat acquired other specialized comics publishers, such as Vents d'Ouest and Drugstore, that added new elements to the already extensive Glénat supply, among others reprints of classical comics and innovative comics. With these new imprints, Glénat made its comics supply for the French market even more complete. One of the biggest bestsellers in the French-language market in the 1990s and early 2000s was *Titeuf* by Zep, and its success led Glénat to start the magazine *Tcho!* around Zep's characters.

In the 2000s, when author albums and graphic novels had become popular, Glénat introduced comics in deviating formats, such as the square Carrément BD series, and comics versions of novels.

In the late 1980s and early 1990s, Glénat was the first French publisher to introduce manga to France and—via Glénat Benelux—also to Belgium and the Netherlands. The first series translated (from Japanese into French and Dutch) were Akira and DragonBall. Soon, these series became very popular among a younger audience than that of the regular French comics album series. After these successes, other publishers also introduced manga to European countries, such as Dargaud with its manga imprint Kana.

In 2007, due to the fast-growing market for manga internationally, the English-language division of Viz Media, a Japanese joint venture that was already active in, among others, the US and the UK, started its own subsidiary in France. For younger audiences, French or Dutch translations of manga were no longer necessary, which made it much more efficient for Viz to distribute the existing English-language editions in Europe. At the same time, these popular English-language editions made it more difficult for Glénat and Kana to sell as many copies as before of their French and Dutch translations. In the early 2010s, both publishers stopped producing Dutch-language versions of manga, as the market had become too small to support them.

5.2.4 Oog & Blik (Dutch de novo)

Oog & Blik (O&B) was founded in 1992. It is a typical Dutch de novo comics publisher: a small organization founded to specialize in publishing high-quality comics albums. Joost Swarte, a co-founder of O&B who is not only a comics artist but also an organizer and designer, played an important role in gaining recognition for comics as a form of art in the Netherlands.[4]

O&B introduced young Dutch artists to the market while also producing translations of artistic comics (author albums and graphic novels). To reach a broader audience than that of the specialized comics shops, O&B cooperated with literary publisher De Harmonie to enhance the distribution of their comics albums in bookshops.

As a member of an international network of artists and publishers who introduced new forms of comics, Joost Swarte used his knowledge to increase the legitimacy of comics as an artistic medium in the Netherlands. One of his strengths was his ability to switch between the role of an artist (aesthetic logics) and that of an entrepreneur (market logics).

Swarte stimulated the symbolic production of artistic comics albums by lobbying for comics at a governmentally supported arts foundation, where he successfully argued that comics had developed into an art form and, as such, should be a part of the foundation's arts policy. In 1998, this success led to grants for comics in the Netherlands. Since then, a selection of the best young Dutch comics artists have received government subsidies, which enable them to devote time to their artistic work without having to meddle with more commercially oriented assignments. Like VNU, O&B also took over comics publishing practices from another comics publisher, in O&B's case the French de novo publisher Futuropolis, with whom Joost Swarte had also published his own book *Swarte: Hors série* (Swarte, 1984) before.

Internal subsidies from more commercial, less costly translated comics enabled O&B to continue offering publication opportunities to young, still unknown artists. By 2010, the small size of O&B's market had made it more difficult to survive independently, which led to its acquisition by literary publisher De Bezige Bij, one of the most prestigious literary publishing houses in the Netherlands. This acquisition had become attractive for De Bezige Bij because of the increasing status and popularity of author albums and graphic novels, which were the core of O&B's publishing list.

However, due to the decreasing market for comics in the Netherlands, De Bezige Bij published fewer comics than Joost Swarte aspired to, and the companies split again after a few years.

In 2014, Wiebe Mokken started the new specialized comics publishing company Scratch, which can be seen as a sequel to O&B, because not only did Scratch publish artistic comics comparable to those O&B had published before, but many former O&B artists' new books were now published by Scratch. Moreover, Joost Swarte became Scratch's main advisor.

5.2.5 Bries (Belgian de novo, Flemish)

Bries started as a comics library in Antwerp, founded in 1985 by Ria Schulpen. In 1990, Bries obtained the legal status of a not-for-profit foundation ('Vereniging Zonder Winstoogmerk'). Later, Schulpen started a comics shop specializing in international small press comics.[5] Soon she also started publishing comics albums— mainly alternative, innovative ones—in varying formats. In 1999, Schulpen decided to work professionally as a publisher. Since then, Bries has been active as a comics shop, gallery, and publishing company.

Schulpen began publishing to add more variety to the existing supply of comics, aspiring to introduce young, mostly still unknown comics artists from the small press scene to a wider international audience. These artists experimented with new formats and new styles of drawing and narrating, using the comics medium in an innovative way. In addition to these innovative comics, Bries also published albums with a traditional format.

As in the Netherlands, the Flemish government started to support young, experimental comics artists, in 2001. Bries was among the most active publishers in this area; thus, together with another Flemish comics publisher, it received the largest amount of subsidies for co-financing comics albums by Flemish artists.

Bries has remained small and independent, and although Schulpen's comics are professionally published, it is still closely linked to the small press movement. Bries' comics have evolved from mainly international productions in English into mainly Dutch-language productions by Flemish and Dutch artists. Bries is innovative in publishing books by experimental and artistic young creators from Flanders, the Netherlands, and abroad. It cooperates with other publishers to share risks and enhance distribution possibilities. In comparison with O&B, Bries has published relatively more originally Dutch-language comics.

Schulpen's aim is to bring to a wider audience those comics that originally were only distributed in the 'scene' of small press artists. She does not aspire to grow and change into a mainstream publisher, and therefore she consciously chose the structure of a non-profit organization.

5.3 Cross-case analysis

The above findings have described the shift from de alio to de novo publishers in the population of Dutch-language comics publishers. This shift was related to the evolution of the main format for comics in recent decades—that is, the shift from magazines to albums. Publishers use different editorial and distributional practices for each of these formats, and both de alio and de novo publishers copy these practices from other publishers, either in their own country or across national borders. De alio publishers (VNU and Dupuis) copied not only from de novos but also from other de alios. De novo organizations (Glénat, O&B, and Bries) were not the only publishers who introduced innovations, but the most radical ones (author albums and graphic novels) came from them. Innovative albums would not have been produced by the de alio publishers if they had not been preceded by comparable books from artist-focused de novo publishers.

In the period when the album became comics' main publication format, the practices of both de alio and de novo publishers were based on a mixture of aesthetic and market logics, but aesthetic logics were more prevalent among the latter. This can be seen, for example, in the activities O&B's co-founder Joost Swarte developed to legitimize artistic comics, as well as in the idealism of Bries' founder and owner Schulpen, who did not even want to make a profit from her comics sales.

The conclusion regarding the logics of de alio publishers in the comics album era depends on the level of analysis. Aesthetic logics became more important overall, but within the de alios this is the case mostly at the editorial level, while at the management level market logics still prevail in these organizations. Thus, compared to de novo

publishers, for de alio publishers there is a stronger differentiation between aesthetic and market logics.

Tables 5.1 and 5.2 give an overview of the logics and practices of both organizational types, add other relevant characteristics, and show how de alios were affected by the changes in the field resulting from the rise of the de novos.

Table 5.1 Logics and characteristics of de alio and de novo comics publishers

Logics and characteristics	Origin		
	A. De alios before interaction	B. De novos	C. De alios after interaction with de novos
Timeline	*1945–1970s*	*1970s–1990s*	*1980s–1990s*
Logics	Market: focus on marketing, primarily profit-driven. Comics seen as a derived product.	Aesthetic: focus on artists, ideal-driven, but to some extent also based on market logics. Comics seen as the core product.	Differentiation of values within the organization: partially aesthetic (editors), partially market (managers) logics. Comics seen as one of the core products.
Products	Magazines and formula-based album series.	Authors' albums, graphic novels, magazines, genre album series.	Reprints and new formula-based album series, combined with a selection of authors' albums or graphic novels.
Audiences	Broad, general audience: children and families.	Specific audiences: adolescents, adults, comics fans, artists.	Combination of general and specific audiences.
Position of artists	Often anonymous artists who work in studios, long-term contracts with publisher. Title of series more important than name of artist.	Artists have creative autonomy. They work individually, sometimes in small teams. For smaller de novos, name of artist more important than title of album or series.	For authors' albums and graphic novels, artists have a degree of creative autonomy. Due to tension between editors and managers this autonomy is sometimes at risk.

Table 5.2 Practices of de alio and de novo comics publishers

Practices	Origin		
	A. De alios before interaction	B. De novos	C. De alios after interaction with de novos
Timeline	1945–1970s	1970s–1990s	1980s–1990s
Production-related capabilities	Use of industrial formulas, based on scale advantages: stories pre-published in magazines, series, fixed length of albums, high-number production.	Scope instead of scale, no strict formulas: sometimes not published earlier, not always series ('one-shots': complete story in one album), length varies, production in modest numbers.	Combination of A and B, depending on market segment.
Distribution	Magazine stores, warehouses, subscriptions to magazines.	Specialized comics stores, bookshops.	Combination of A and B.
Prices	Fixed, low.	Variable, can be as high as a literary novel or a coffee table book.	Combination of A and B.
Resources	Comics and their creators 'owned' by publisher. Market knowledge.	Publishers and editors with networks of artists and with editors from other (foreign) publishers. Inside knowledge of comics.	Market knowledge, ownership of classical album series, combined with editors recruited based on inside knowledge of comics (as former de novo editors or comics fans).

Notes

1 The database used only contains Dutch-language publishers. If French-language publishers were included, the development would likely show an earlier shift towards a majority of de novo publishers.
2 Figure 5.2 only visualizes the data for 1945–1994, the period in which the differences between the two types of organizations manifested.
3 Many comics from *Spirou* (e.g. *Lucky Luke, The Smurfs*) became very popular and are now part of the European 'comics canon'.

4 Appendix II provides a more detailed analysis of the role(s) that Joost Swarte played in these processes.
5 Small press comics are produced and distributed by the artists who created them, usually on a small scale.

Bibliography

Bellefroid, T. 2005. *Les éditeurs de bande dessinée. Entretiens avec Thierry Bellefroid.* N.p. (Belgium): Niffle.
Bellefroid, T. 2005. 'Glénat: Jacques Glénat'. In: *Les éditeurs de bande dessinée. Entretiens avec Thierry Bellefroid*, 78–91. N.p. (Belgium): Niffle.
Bellefroid, T. 2008. *Le roman d'aire libre.* N.p. (Belgium): Dupuis.
Béra, M., M. Denni, andP. Mellot. 1996. *Trésors de la bande dessinée. BDM 1997–1998.* Paris: Les éditions de l'amateur.
Brok, H., E. Pommerel, and J. Swarte. 1977. De klare lijn. Vierde schrift. Vol. 5 of *Achtergronden van het beeldverhaal*. Rotterdam: Rotterdamse Kunststichting.
Brok, H. and R. van Eijck. 1986. 'Kommercie en artisticiteit: Jos Wauters over Robbedoes, Spirou, Dupuis en De Standaard.' *Stripschrift*, nr. 204.
Brunsmann, J. 1998. *Strip in Beeld. Ambitie en ambivalentie in de Nederlandse stripwereld.* University of Amsterdam (unpublished MA thesis).
Challe, M. and A. Dujardin. 2010. *Les éditeurs de bande dessinée et de la littérature pour la jeunesse.* Brussels: SMartbe.
Daalder, M. (ed.). 1991. *Stripjaar 1990*. Amsterdam: Sherpa.
Daalder, M. 1992. 'Joost Swarte: De Twijfel Voorbij'. In: M. Daalder (ed.), *Stripjaar 1991*, 84–96. Amsterdam: Sherpa.
Dayez, H. 1997. *Le duel Tintin-Spirou.* Brussels/Paris: Editions Luc Pire/Les Editions Contemporaines.
De Groot, M. 1992. 'Joost Swarte: Na Haarlem wordt alles anders.' *Stripschrift*, nr. 4.
De Laet, D. 1985. *L'Affaire Dupuis. Dallas sur Marcinelle.* Brussels: NCM Editions.
De Laet, D. and Y. Varende. 1979. *De zevende kunst voorbij. Geschiedenis van het beeldverhaal in België.* Brussels: Ministerie van Buitenlandse Zaken.
De Vries, R. 2014. 'Balancing on the "Clear Line": between Selecting and Being Selected. Independent Comics Publishing in the Netherlands: the Case of Joost Swarte and Oog & Blik'. In: C. Dony, T. Habrand, andG. Meesters (eds.), *La bande dessinée en dissidence. Alternative, indépendance, auto-édition/Comics in Dissent. Alternative, Independence, Self-Publishing*, 113–125. Liège: Presses Universitaires de Liège.
De Waal, J. 2008. 'Gewoon overtekenen. De introductie van *Sjors van de rebellenclub*, een casestudy naar onopgemerkte amerikanisering' *Sociologie*, 4, 115–134.
De Weyer, G. (ed.). 2005. *Stripjaar 2004.* Castricum: Sherpa.
Derscheid, J.M. and D. Pasamonik. 2009. *Het Belgisch stripverhaal. Een kruisbestuiving.* N.p. (Belgium): Uitgeverij Snoeck.

Dierick, C. and P. Lefèvre. 1996. 'Strips in België, een te regionaliseren materie?' *DWB*, 141, 464–471.
Dohmen, T. 1999. 'Juichkreten en doemscenario's. De stripmarkt in 1998'. In: M. Schifferstein, J. Pollmann, P. van Oudheusden, and P. Kuipers (eds.), *Stripjaar 1998*, 30–38. Amsterdam: Sherpa i.s.m. Stichting Beeldverhaal Nederland.
Dohmen, T. 2000. 'Tekenen van herstel'. In: M. Schifferstein, M. Verbeek, P. van Oudheusden, and P. Kuipers (eds.), *Stripjaar 1999–2000*, 24–34. Amsterdam: Sherpa i.s.m. Stichting Beeldverhaal Nederland.
Gianati, L., L. Cirade and S. Farinaud. 2019. 'Glénat: 50 ans d'édition. Entretien avec Jacques Glénat.' *BD Gest'*. https://www.bdgest.com/news-1326-BD-Glenat-50-ans-d-edition.html.
Glénat 40 ans d'édition. Catalogue BD 2009. Grenoble: Glénat.
Johannes, G. and M. Cohen de Lara. 2005. *Van Haarlem naar Manhattan. Veertig jaar VNU 1965–2005*. Amsterdam: Boom.
Kousemaker, K. and E. Kousemaker. 1979. *Wordt vervolgd. Stripleksikon der Lage Landen*. Utrecht: Het Spectrum.
Lecigne, B. 1983. *Les héritiers d'Hergé*. Brussels: Editions Magic Strip.
Lecigne, B. 1984. 'Lecture'. In: J. Swarte, *Swarte, Hors série*, 9–14. Paris: Futuropolis, and Amsterdam: Het Raadsel.
Lefèvre, P. 1986. *De selekterende stripuitgevers. Een onderzoek naar de gatekeeping bij de grote stripuitgeverijen Lombard en Dupuis*. Universiteit van Leuven (unpublished MA thesis).
Lefèvre, P. and M. Di Salvia. 2010. *Strips en illustratie in België. Een stand van zaken en de sociaaleconomische situatie van de sector*. Brussels: SMartBe.
Marktonderzoek Reeskamp. 1973. *De losse verkoop van stripverhalen in Nederland*. Bussum: Marktonderzoek Reeskamp.
Matla, H. 1998. *De Stripkatalogus – De negende dimensie*. Den Haag: Panda.
Matla, H. 2000. 'Van centsprent tot album. De ontwikkeling van het stripverhaal 1800–2000'. In: B. Dongelmans, N. van Rotterdam, J. Salman, and J. van der Veer (eds.), *Tot volle waschdom. Bijdragen aan de geschiedenis van de kinder- en jeugdliteratuur*, 57–72. Den Haag: Biblion Uitgeverij.
Meesters, G. 2010. 'De internationalisering van de Vlaamse strip'. In: Z. Hrnčiřová, K. Mercks, J. Pekelder, E. Krol, and J. Ultzen (eds.), *Praagse Perspectieven 6*, 113–130. Praag: Universitaire Pers.
Nieuwenhuis, J. 1999. 'Tussen markt en missie. De ondankbare taak van de stripuitgever'. In: M. Schifferstein, P. van Oudheusden, and P. Kuipers (eds.), *Stripjaar 1998*, 39–46. Amsterdam: Sherpa i.s.m. Stichting Beeldverhaal Nederland.
Peniston, D. 2006. 'Joost Swarte Interview.' *The Comics Journal*, nr. 279.
Pollmann, J. 1999. 'De geschiedenis van de strip in Nederland.' *Stripgids*, nr. 35.
Schifferstein, M. (ed.) 1998. *Stripjaar 1997*. Amsterdam: Sherpa, i.s.m. Stichting Beeldverhaal Nederland.
Schifferstein, M., M. Snoodijk, and G. de Weyer (eds.) 1996. *Stripjaar '95–'96*. Amsterdam: Sherpa.
Schifferstein, M., J. Pollmann, P. van Oudheusden, and P. Kuipers (eds.) 1999. *Stripjaar 1998*. Amsterdam: Sherpa i.s.m. Stichting Beeldverhaal Nederland.

Schifferstein, M., M. Verbeek, P. van Oudheusden, and P. Kuipers (eds.) 2000. *Stripjaar 1999–2000*. Amsterdam: Sherpa i.s.m. Stichting Beeldverhaal Nederland.
Screech, M. 2005. *Masters of the Ninth Art. Bandes Dessinées and Franco-Belgian Identity*. Liverpool: Liverpool University Press.
SDCN. 2005. *SDCN-database*. 2005. Amsterdam: Strip Documentatie Centrum Nederland. (Excel file for internal use by SDCN, data used with permission of SDCN; SDCN is a part of the University Library of the University of Amsterdam).
Swarte, J. 1984. *Swarte: Hors Série*. Paris: Futuropolis and Amsterdam: Het Raadsel.
Swarte, J. 1998. 'Wat is er mis met de Nederlandse strip?' *Trouw*, June 6.
Van den Boom, H. 1977. 'De Haarlemse stripbladen. Een gesprek met Peter Middeldorp.' *Stripschrift*, nr. 104.
Van den Boom, H. and P. de Raaf (eds.) 1986. *Stripjaarboek '85–'86*. Aerdenhout: Arboris.
Van der Linden, F. 1994. '"Dit is een vak, geen godsdienst". Peter Middeldorp en de "kunst" van het bladen maken.' *De Journalist*, nr. 9.
Van Eijck, R., H. Brok, and B. Dekker Jr. 1986. 'Erwin Cavens vertelt: De problemen bij Dupuis.' *Stripschrift*, nr. 204.
Venema, T. 2005. *Je krijgt geen geld, maar tijd. Een onderzoek naar subsidieverstrekking aan stripmakers door het Fonds BKVB*. Rijksuniversiteit Groningen (unpublished MA thesis).
Vranken, P., L. Vranken, and H.Matla. 2001. *The Collector's File*. N.p. (Belgium): Amber-VM (CD-ROM).
Weyer, G.de. 2006. 'Paul Herman. Voorvechter van manga en vierkant denken. 20 jaar Glénat Benelux'. In: G. de Weyer (ed.), *Stripjaar 2006*, 108–109. Amsterdam: Sherpa.
Zeegers, G. 2009. 'De Nieuwe Vlaamse Golf.' *Zozolala*, nr. 165.

Websites for comics fans and collectors, and websites of publishers

BD Gest'. http://www.bdgest.com/.
BDoubliées. http://www.bdoubliees.com/.
Bedetheque. http://www.bedetheque.com/.
Bries. http://www.bries.be/.
Catawiki. http://www.catawiki.nl/catalogus/1888-strips.
De Stripspeciaal-Zaak. http://www.stripspeciaalzaak.be/.
Dupuis. http://www.dupuis.com.
Glénat. glenat.com
Lambiek.net. http://www.lambiek.net/1/home.htm.
Média Participations. http://www.media-participations.com/.
Oog & Blik. http://www.oogenblik.nl/.
Scratch. https://scratch-books.com/.

List of interviewees (interviews with R. de Vries)

Name of interviewee	(Former) function	Case organization	Date of interview	Location of interview	Length of interview (hours: minutes)
Ria Schulpen	Publisher	Bries	28/5/2009	Antwerpen	1:24
Erwin Cavens	Editor	Dupuis	21/4/2009	Brussels	1:23
Peter Middeldorp	Editor	Dupuis, VNU	2/7/2009	Bloemendaal	0:41
Paul Herman	Publisher for Glénat Benelux	Glénat	23/4/2009	Brussels	1:55
Hansje Joustra	Publisher	O&B	16/5/2006	Amsterdam	1:35
Joost Swarte	Artist, designer, publisher, expert	O&B	12/6/2006	Haarlem	2:25
Mat Schifferstein	Publisher, translator	O&B	12/2/2009	Amsterdam	1:50
Ron Poland	Distributor	O&B, Het Raadsel	16/6/2009	Hilversum	0:54
Hans van den Boom	Editor	VNU	13/1/2009	Zelhem	3:18
Thom Roep	Editor	VNU	25/3/2009	Hoofddorp	1:56
Ger van Wulften	Layout	VNU	14/5/2009	Amsterdam	1:19
Frits van der Heide	Editor, translator	VNU (Oberon)	2/4/2009	Zandvoort	1:09
Rob Harren	Marketing manager	VNU (Oberon)	14/5/2009	Haarlem	1:48
Meerten Welleman	Album editor	VNU (Oberon, Big Balloon)	27/3/2009	Amsterdam	1:43
Cees de Groot	Editor, publisher	VNU (Oberon, Big Balloon)	7/7/2009	Amsterdam	0:50

6 Discussion

According to Hsu and Hannan (2005), the ratio of de alio to de novo organizations determines the identity of a niche. As the findings have shown, de alio publishers dominated the comics industry until 1988, when de novo publishers became the majority. This implies that the comics niche has only relatively recently developed the identity necessary for organizations in that niche to 'emerge as legitimate, established types' (Hsu and Hannan 2005, 481).

The case analyses show that organizations in the same niche with different origins interact with each other. Because the practices based on aesthetic logics that were dominant among de novos became increasingly important, de alios copied these practices from them in order to survive. To do so, de alio publishers hired fans and creators of comics as editors, as these individuals were part of the network of comics creators and had the same attitude towards comics as the de novo publishers. These new editors were given relative autonomy in their publishing strategies. Thus, aesthetic logics became more important for all comics publishers in the shift from comics magazines to comics albums.

These field dynamics are also related to changes in comics audiences. The demands and expectations of the new audiences—artists as well as adolescent and adult comics buyers and fans—differ from those in the era of comics magazines and require more knowledge about the medium and more attention to artistic input.

Dupuis, after its acquisition by GBL, had identity aspirations (Kodeih and Greenwood 2014) that led to a new identity. Dupuis continued to produce comics for a broad audience but simultaneously published innovative comics albums for small niches which originally were the domain of de novo specialists. Seen from the resource partitioning perspective, Dupuis changed from a generalist into a *polymorphist*: a hybrid between generalist and specialist organizations, offering products in the

market centre as well as in the periphery (Wezel and Van Witteloostuijn 2003). Due to its fast growth, Glénat developed in the same direction, but as a de novo publisher it had a different starting point: it changed from a specialist into a polymorphist.

Although the editorial logics of the Dutch publisher VNU also changed in the same direction as those of the de novos, VNU was not able to make the same radical change that Dupuis did. In the end, VNU even stopped publishing comics altogether. Because of Belgium's geographic position between France and the Netherlands, as well as its bilingual culture, it has bigger market potential than the Netherlands. Thus, Dupuis was able to reach sub-niches big enough for the publisher to remain profitable. This situation makes Belgium and France better equipped than the Netherlands for polymorphist comics publishers.

De alio publishers VNU and Dupuis introduced practices based on aesthetic logics, but this choice was made by their management for instrumental reasons—in contrast to the intrinsic motivation of the de novos, who started publishing because of their attachment to comics. The fact that the de alios copied the prevailing aesthetic logics of the de novos in the comics album niche is a clear example of isomorphism (DiMaggio and Powell 1983). It appears that neo-institutional theory's view on field dynamics has not lost its explanatory power.

Unfortunately, Média Participations, which acquired Dupuis, broke the delicate balance between aesthetic and market logics by interfering with Dupuis' editorial autonomy. This immediately led to protest actions and the departure of both artists and editors. In the cultural industries, to which comics album publishers belong, the balance between conflicting logics is crucial (Lampel, Lant, and Shamsie 2000), making it risky to prioritize one over another.

Bibliography

DiMaggio, P.J. and W.W. Powell. 1983. 'The iron cage revisited: Institutional isomorphism and collective rationality in organizational fields.' *American Sociological Review* 48: 147–160.

Hsu, G. and M.T. Hannan. 2005. 'Identities, genres and organizational forms.' *Organization Science* 16: 474–490.

Kodeih, F. and R. Greenwood. 2014. 'Responding to institutional complexity: The role of identity.' *Organization Studies* 35: 7–39.

Lampel, J., T. Lant, and J. Shamsie. 2000. 'Balancing Act: Learning from Organizing Practices in Cultural Industries.' *Organization Science* 11: 263–269.

Wezel, F.C. and A. van Witteloostuijn. 2006. 'From scooters to choppers: Product portfolio change and organizational failure.' *Long Range Planning* 39: 11–28.

7 Conclusions

This book's main question has been to what extent the origins of organizations have impacted the institutional logics in the comics industry. For this purpose, organizational origin was related to logics in the field of Dutch-language comics publishers. The categories of de alio and de novo organizations, derived from organizational ecology, were used as the main distinction between organizations regarding their origins.

After the shift from magazines to albums as the main format for Dutch-language comics in the period 1945–1994, the de alio/de novo ratio gradually shifted to the advantage of the latter. Comics albums and their audiences (buyers and artists) demanded a more specialized approach than that of magazines, and de novos were better able than de alios to cope with these demands. De novo publishers' practices were therefore copied by de alios, and the industry consequently developed from being largely market-oriented to placing more importance on aesthetics. This shift contributed to a change in identity of the comics field. For individual de alio organizations, this meant that if they aspired to stay within the field, they also had to adapt.

A more general implication of these outcomes is that large organizations do not, by definition, dominate over smaller organizations in the same field. If the dominant practices in a field are those that prevail in smaller organizations (usually de novos), larger organizations (usually de alios) can be forced to copy those practices, indirectly affecting the latters' logics.

Earlier institutional research has described institutional dynamics moving from product to market logics (Fligstein 1990; Thornton 2004)—or, in terms of cultural industries, from aesthetic to market logics. However, the analysis explored the possibility of big companies' institutional dynamics moving in an alternative direction—that is, from market to aesthetic logics.

DOI: 10.4324/9781003328179-7

A limitation of case studies is that they inherently focus on a limited number of companies. For this research, polar cases were chosen, due to their expected contribution to the construction of theory. For inductive research, this is a valid approach, but for future deductive research a more representative sample of de alio and de novo organizations is needed.

The conclusions drawn here point in a direction comparable to that of research in another creative industry: that of popular music. Huygens, Baden-Fuller, Van den Bosch, and Volberda (2001) show how, in the pre-digital 20th century, the evolution of the main publication format for pop music (from the 'single' to the LP) forced the major record companies to pay attention to practices introduced by smaller, specialized, independent record companies. The latter's practices, like those of the de novo publishers in this research, were also based on a mixture of market and aesthetic logics, whereas those of the former, like the de alio publishers, were mainly based on market logics. This is also how the major companies survived: by acquiring or forming alliances with independent record companies. For future research, it would be interesting to investigate whether the change from market to a mixture of market and aesthetic logics can also be found in other creative industries with audiences that expect an increased level of specialization, as well as what survival strategies are used and what the findings imply for the field.

Finally, the relevance of the interaction between de alio and de novo publishers to understanding how a niche develops, as shown in earlier research (McKendrick and Carroll 2001; Hsu and Hannan 2005; Perretti, Negri, and Lomi 2008), is confirmed here using a new approach: a combination of concepts from organizational ecology and institutional logics. Research based on this combination can add depth to our understanding of the development of organizational fields. Therefore, it should be explored in other industries as well.

Bibliography

Fligstein, N. 1990. *The Transformation of Corporate Control*. Cambridge, MA: Harvard University Press.

Hsu, G. and M.T. Hannan. 2005. 'Identities, genres and organizational forms.' *Organization Science* 16: 474–490.

Huygens, M., C. Baden-Fuller, F. A.J. van den Bosch, and H.W. Volberda. 2001. 'Co-evolution of Firm Capabilities and Industry Competition: Investigating the Music Industry, 1877–1997.' *Organization Studies* 22: 971–1011.

McKendrick, D.G. and G.R. Carroll. 2001. 'On the genesis of organizational forms: Evidence from the market for disk arrays.' *Organization Science* 12: 661–682.

Perretti, F., G. Negro, and A. Lomi. 2008. 'E Pluribus Unum: Framing, Matching, and Form Emergence in U.S. Television Broadcasting, 1940–1960.' *Organization Science* 19: 533–547.

Thornton, P.H. 2004. *Markets from Culture: Institutional Logics and Organizational Decisions in Higher Education Publishing*. Stanford, CA: Stanford Business Books.

Appendix I: The role of religion in the reading of comics

As shown in Chapter 2, comics can be much more popular in one country than in another, even in the case of neighbouring countries like France, Belgium, and the Netherlands. Differences can even exist across regions within a country, as in the case of Flanders and Wallonia.

Comics represent an aesthetic medium and a tangible form of culture. Culture, as defined by norms and values, is intangible. Much empirical research has been conducted on the role of intangible culture in explaining differences between countries, but less is known about the relationship between tangible and intangible culture. Understanding this relationship might help us understand why comics are more popular in one country than in another. To this end, this appendix will test insights from earlier sociological research based on people's values—the World Values Surveys (WVS)—on readers of comics.

According to Inglehart and Baker (2000), who used WVS data and are among the main scholars behind these surveys, the religious past of a country has an effect on the norms and values of its inhabitants up to the present. In fact, cultural values derived from religious institutions can have such a long-lasting effect on societies that, in spite of optimistic theories that began during the Enlightenment period, modernization and globalization do not necessarily bring societies much closer to each other. Different religious histories even lead to cultural differences *between* countries that surpass those between religious denominations *within* a country. However, it is not clear whether this religious past also affects a country's present-day *tangible* culture.

Inglehart and Baker (2000: 22) mention Weber's (1904) claim that 'traditional religious values have an enduring influence on the institutions of a society'. Weber focuses in particular on the Protestant ethic, which has had a strong influence on the development of capitalist societies. This ethic includes values related to working hard and developing oneself through, among other means, education and reading.

Appendix I: The role of religion in the reading of comics

The interpretation of the Ten Commandments by the founders of Protestantism, especially Calvin and his followers, differed from that of the Catholic Church and led to a Protestant culture that also differed from the Catholic culture. Among other differences, the Catholic culture is traditionally considered to be more visually oriented, whereas the Protestant culture is considered to be more text-oriented.

The importance of text and reading for Protestants is expressed in the *'sola scriptura'* principle, referring to their belief in the divine authority of the Bible. Followers of Calvin's interpretation of Protestantism maintained this principle and thus sought to ensure all followers could read the Bible by introducing translations of the Bible. Indirectly, this focus on the Bible and related efforts to stimulate reading also led to more attention to books in general. This helps to explain why reading in general is more popular in Protestant than in Catholic countries, and why, at the individual level, Protestants read more than Catholics regardless of where they live (De Vries, forthcoming).

Despite their textual elements, comics are often seen as a primarily visual medium. Therefore, based on the differences outlined above, one might expect that they are read more in countries where Catholic values prevail than in countries with a Protestant history (also see Frenzel 2000). The comparisons in this book seem to confirm this reasoning, as comics are more popular in the Catholic countries of France and Belgium than in the Protestant country of the Netherlands. However, does this finding also imply that comics are more widely read among Catholics than among Protestants, regardless of their country of residence?

Not all countries/regions collect data that can give us insight into the religious affiliation of comics readers. The Netherlands, Flanders, and Wallonia do so, but unfortunately France does not. Recent nationwide surveys from France collected information about reading comics but not about the respondents' religion. For this reason, the following comparison is limited to the Netherlands and both regions of Belgium.

For a valid comparison, the data for each country/region must be similar. This appeared to be possible based on the available data, as the surveys used in this book are from the same three-year period: 2004 for Flanders, 2005 for the Netherlands, and 2007 for Wallonia (sources: Flanders: Steunpunt voor Beleidsrelevant Onderzoek Cultuur, 2004; the Netherlands: TBO, 2005; Wallonia: Observatoire des politiques culturelles—OPC, 2007). The nationwide surveys measured time spent and cultural participation. Among other topics, they covered reading various genres of books, including comic books. The respondents' religion was one of the demographic variables collected, along with, among others, age, gender, educational level, and income.

Appendix I: The role of religion in the reading of comics

A first assumption, based on (1) the characteristics of comics, (2) the differences between Protestant and Catholic religious cultures, and (3) the different religious histories of both countries, is that comics are read more in Flanders and Wallonia than in the Netherlands. This proposition has already been confirmed (see findings in Chapter 2, and see Table 2.2 and Figure 2.1).

These findings suggest that the popularity of comics is related to the more visually oriented Catholic culture. However, this is contradicted by the outcomes of a second test, based on the assumption that among *individual* readers of comics there are relatively more Catholics than Protestants in both countries. This assumption is rejected: an analysis of the characteristics of comics readers reveals that, in the three countries/regions, Catholics do *not* read comics more often than Protestants; in fact, the reverse is true (see Figure App. I and Table App. I).

Regarding other types of books, Protestants also read more than Catholics do in Belgium and the Netherlands. Thus, although comics are a hybrid cultural medium that mixes visual with textual elements, the religious profile of their readers does not significantly differ from that of readers of other types of books.

Figure A.I Reading comics and religion
Explanatory notes: Percentages of respondents who have read comic albums in the preceding twelve months (six months for Flanders).
Sources: National enquiries into cultural participation (Wallonia: Observatoire des politiques culturelles—OPC, 2007; Netherlands: TBO, 2005; Flanders: Steunpunt voor Beleidsrelevant Onderzoek Cultuur, 2004).

Appendix I: The role of religion in the reading of comics

A third assumption, based on earlier WVS research about intangible dimensions of culture, is that the differences (distances) between Catholic and Protestant comics readers *within* a country are smaller than those *between* countries. This assumption is confirmed (see Table App. 1), with differences of approximately 8% and 18%, respectively.

These findings indicate that religious denomination and the reading of comics are correlated, which confirms the importance of religion as an institution; however, when controlling for other demographical variables such as age, gender, and education, it appears that some of these variables have a stronger predictive value. Age is particularly important: perhaps not surprisingly, young people read comics significantly more often than older people do in each of the countries/regions studied, including France.[1] Gender is also related to reading comics: in the Netherlands, Belgium, and France, men read comics more often than women.

Regarding education level, a striking difference can be seen between the Netherlands and the other two countries. In France and Belgium, reading comics is positively correlated with a higher education level, whereas in the Netherlands this relationship is negative. This difference could be caused by comics' relatively high level of legitimacy as a cultural medium in France and Belgium (Lesage 2019 and 2023).

Table A.I Reading comics and religion: differences within and between countries

	Catholics	Protestants	Total population	Distance between Catholics and Protestants within a country
Wallonia 2007	34%	44%	36%	10%
Flanders 2004	21%	29%	26%	8%
Netherlands 2005	9%	16%	14%	7%
Distance of *same* religion *between* the countries	17%	19%		Average of column (religious distances within countries): 8%
				Average of row (distance of same religion between countries): 18%

Sources: National enquiries into cultural participation (Wallonia: Observatoire des politiques culturelles—OPC, 2007; Netherlands: TBO, 2005; Flanders: Steunpunt voor Beleidsrelevant Onderzoek Cultuur, 2004).

Explanatory notes: Percentages of respondents who have read comic albums in the preceding twelve months (six months for Flanders).

Appendix I: The role of religion in the reading of comics

In conclusion, there is no proof of a direct causal relationship between Catholic culture and the popularity of comics. Context-specific historical factors, including the early production and supply of originally Belgian comics (among others, those by Hergé) and the following rapid rise and broad legitimacy of French comics, offer a better explanation for the differences between the countries.

Note

1 This information about France comes from Berthou et al. (2015), Evans and Gaudet (2012), and Guilbert (2021).

Bibliography

Berthou, B. et al. 2015. *La bande dessinée: quelle lecture, quelle culture? Études et recherche*. Paris: Bibliothèque Centre Pompidou.

De Vries, R. (forthcoming). 'Sola Scriptura: reading as a persistent fundament of Protestant human capital' (working title).

Evans, C. and F. Gaudet. 2012. 'La lecture de bandes dessinées.' *Culture études*, 2012–2.

Frenzel, M. 2000. 'Protestantische Comic-wüste Germanien? Deutsche Autorencomics der 80er und 90er Jahre (1980–2000). Eine Bestandsaufnahme aus der Vogelprespektive'. In: B. Ihme, M. Frenzel, and A. Dierks (eds.), *Comic! Jahrbuch 2000*, 40–77. Stuttgart: Interessenverband Comic e.V. ICOM.

Guilbert, X. 2021. *Panorama de la BD en France 2010–2020*. Paris: Centre National du Livre.

Inglehart, R. and W.E. Baker. 2000. 'Modernization, Cultural Change, and the Persistence of Traditional Values.' *American Sociological Review* 65: 19–51.

Lesage, S. 2019. *L'Effet livre. Métamorphoses de la bande dessinée*. Tours: Presses universitaires François-Rabelais.

Lesage, S. 2023. *Ninth Art. Bandes dessinée, Books and the Gentrification of Mass Culture, 1964–1975*. Cham: Palgrave MacMillan/Springer Nature Switzerland AG.

Observatoire des politiques culturelles–OPC. 2007. *Enquête relative aux pratiques culturelles, aux. loisirs des 16 ans et plus résidant en FW-B de 2007, données récoltées par IPSOS*.

Steunpunt voor Beleidsrelevant Onderzoek Cultuur. 2007. *Participatiesurvey 2003–2004*.

TBO. 2005. *Sociaal en Cultureel Planbureau (01/08/2005–14/11/2005) Tijdsbestedingsonderzoek 2005 – TBO 2005* (SPSS files). Data deposited at DANS (Data Archiving and Networked Services). Identifier: urn:nbn:nl:ui:13-v64-rd7.

Weber, M. [1904] 1958. *The Protestant Ethic and the Spirit of Capitalism*. New York: Charles Scribner's Sons.

Appendix II: The many roles of Joost Swarte[1,2]

Joost Swarte started publishing comics in 1970. At that time, he was studying at the Academy of Industrial Design in Eindhoven, but he felt more attracted to drawing and gave up his studies. In 1971, he started his own underground comics magazine *Modern Papier* ('Modern Paper'). He also produced drawings for another magazine, called *Tante Leny presenteert* ('Aunt Leny Presents'). Both magazines were among the first European underground publications. In 1972, after ten issues, *Modern Papier* merged with *Tante Leny presenteert*.

In 1973, Joost Swarte compiled the comic album *Cocktail Komix*, for the publisher Tango, with works of Dutch and Belgian underground artists. This was the first and only album in which these artists appeared together. Because of this, one could say that Swarte made a whole of the underground artists. Swarte, because of his initiative, immediately got the position of spokesperson for the Dutch underground comics.

Swarte had developed a drawing style that was influenced by Hergé. In 1977, he was one of the organizers of an exhibition in Rotterdam dedicated to *Tintin*. A part of the exhibition was dedicated to colleagues and followers of Hergé, of which Swarte himself was one. He invented the label 'clear line' (in Dutch '*klare lijn*', and in French '*ligne claire*') to describe the characteristics of Hergé's style, and used this label as the title of one of the four catalogues for the exhibition. Already at this stage, Swarte acted both as an active peer (a comics artist who invites colleagues for an exhibition) and an expert (who theorizes about styles, organizes exhibitions, chooses whom can participate, and invents labels).

Quite quickly, 'clear line' was accepted as the label for this typical European style of drawing comics. Swarte's later popularity in France contributed to the diffusion of the term, and his coining of this label for Hergé's style, in turn, made him even better known. A young

generation of artists who had been raised with the *Tintin* books of Hergé had begun to draw in his style, and now they were put in the cultural tradition of the *'ligne claire'*. Bruno Lecigne's book *Les héritiers d'Hergé* (Lecigne 1983), which includes a chapter about Joost Swarte, was a further recognition of Swarte's innovation of the style of Hergé.

The new label was important for comics critics like Lecigne: it provided them with a tool to analyze and explain developments in comics, and made it possible for them to gain recognition as serious critics.

One of the artists that Swarte had invited to publish in *Cocktail Komix* was Willem (pseudonym of the Dutchman Bernard Holtrop). At that time, Willem was already living and publishing in France. He introduced Swarte to *Charlie Mensuel* magazine. Swarte's stories in *Charlie* were well received, and this success opened other doors for Joost Swarte in France. He published his first French album *L'Art Moderne* for Les Humanoïdes Associés. At that time, he had already met Etienne Robial, co-owner of Futuropolis, who was also interested in Swarte's work. Robial went a step further than 'the Humanoids': he presented comics and drawings by comics artists in luxurious, carefully designed coffee table books. The comics artists were given the status that was formerly reserved to painters and other creators of traditional 'high art'.

Swarte published and exhibited in more and more European countries, as well as in the United States, where, among other things, he drew covers for *The New Yorker*. Art Spiegelman, also a former underground artist with more ambitions than most of his colleagues, invited him to publish in *Raw*. Again, Swarte was part of an important innovation in the area of comics, for *Raw* was the first luxurious, intellectual comics magazine with an international appeal. It was filled with material by a new generation of comics artists from the US and many European countries, and was distributed worldwide.

Futuropolis published a number of books by Swarte, but the most important was perhaps the publication of *Swarte, Hors série* (Swarte 1984). This was a luxurious book with a collection of reproductions of his posters, record and magazine covers, and silkscreens. It included a preface by designer Roman Cieslewicz and an introduction by Bruno Lecigne. It is not surprising to observe that both the idea for the book and for the two introductory texts came from Swarte. The book appears to be a catalogue of an imaginary exhibition, which, according to Lecigne, puts Swarte and his work in a tradition of fine arts as well as comics (Lecigne 1984).

In 1987, Swarte made the virtual exhibition in *Hors série* a real one, when he organized his travelling solo exhibition, ironically named 'The World Exhibition of Joost Swarte'. He did this in cooperation with

Dutch art museums. The exhibition was accompanied by the catalogue *Plano*. Again, this catalogue featured an introduction, this time by the art historian Paul Hefting (Hefting 1987), who put Swarte's oeuvre in a context of art and culture (just like Lecigne had done earlier for *Hors série*). The exhibition travelled through Europe in 1988 with the accompanying catalogue.

Swarte's work had developed into ironic abstractions of the traditional *Tintin*-like comics stories, which added a (post)modern dimension to it that appealed to many young people in the 1980s, and especially to a more intellectual audience. The fact that irony is one of the most important stylistic means and one of the returning motifs in Swarte's comics and illustrations made him the right artist at the right (postmodern) time. He continued experimenting with formats, supported and influenced by Robial, and by other Futuropolis artists. This led to more books, silkscreen prints, posters, and portfolios. This was also one of the first times that a comics artist had produced drawings as independent artworks, and not as a part of a story in a magazine or an album.

In order to distribute *Hors série* in the Netherlands, Swarte stimulated Hansje Joustra, with whom he had cooperated before, to start a distribution company in the Netherlands. Joustra agreed, and Het Raadsel came into life. Now Joost Swarte had his own company to distribute *Hors série* and his other publications outside France. The Dutch edition of the book received page-length positive reviews in quality papers and intellectual magazines (among others, Brok 1984 and Kousbroek 1984). The only critical note was that it was a pity that Joost Swarte had not included comics in the book.

At that time, in 1984, there was one other Dutch distributor of alternative comics, Drukwerk, and when this company stopped its activities, Het Raadsel jumped into the gap. In the years after, Het Raadsel developed into the most important distribution company for innovative comics in the Netherlands. It specialized in distributing comics to the comics shops that were already spread throughout the country in the 1980s.

Since its beginning, Het Raadsel had cooperated with the literary publisher De Harmonie, partly to distribute their books more effectively, and partly because both shared an appreciation for comics and cartoons created by independent spirits. Het Raadsel would distribute the cartoon and comic books published by De Harmonie among comics shops, whereas De Harmonie would distribute Swarte's books in bookshops via Centraal Boekhuis, the largest book distributor in the Netherlands.

Jaco Groot, founder and owner of De Harmonie, was well acquainted with Swarte, and had already published a book by him before Het Raadsel came into existence. De Harmonie was one of the first Dutch literary publishers that published cartoon books and comics albums as an integrated part of their publishing list. It is a small publisher but one with a high status in the Dutch literary world. The mere fact that Groot's De Harmonie published comics made the medium more *salonfähig*.

Apart from distributing, Het Raadsel also published a few albums every year under their own name: among others, books by Joost Swarte. In 1991, the number of their publications increased. Het Raadsel became as much a publisher as a distributor and, in fact, also a competitor of De Harmonie. Joustra and Swarte decided that the distribution and publishing activities would be split into two independent companies, and this decision led to the founding of Oog & Blik (O&B) in 1992. The agreement with De Harmonie continued. Both parties could decide for each publication whether it would be a joint venture or a publication by just one of them. The advantage of their collaboration, a good distribution in ordinary bookshops as well as comics shops, would remain the same.

Swarte and Joustra founded O&B in 1992, and although Swarte later withdrew as a formal co-owner, he would remain involved on a more informal level as an adviser to Joustra. In 2010, O&B was acquired by literary publisher De Bezige Bij. Ten years earlier it would have been unimaginable that this publisher would have shown any interest in a comics publisher. Obviously something had changed in the years in between.

The first album publications under the new name O&B were presented during the new comics festival Stripdagen Haarlem, a festival that was also initiated by Swarte, and which held its first edition in 1992. It quickly became the most important comics festival in the Netherlands. Swarte's model was the comics festival in Angoulême. Just like Haarlem, Angoulême is a relatively small town, where many institutions work together to make the yearly festival a success. Stripdagen Haarlem pays much attention to innovative comics from around the world, and in this way discerns itself from the other Dutch comics festivals. The festival works together with many other cultural institutions—for practical reasons, but mainly to ensure that it is integrated in the cultural infrastructure of the city.

In France, grants for comics artists had been called into life in 1984, when Jack Lang was Minister of Culture. In the Netherlands, it took much longer for the art institutions to be 'ready' for comics. The

possibility of art subsidies for comics artists had not come into the minds of the experts of the Dutch Funds for Visual Arts, Design and Architecture ('Fonds voor Beeldende Kunsten, Vormgeving en Bouwkunst'—FBKVB) spontaneously. Fortunately, Joost Swarte (not only comics artist and organizer of comics-related activities, but also illustrator, designer, and architect) spoke the language of art experts. He told the policymakers of FBKVB that the exclusion of comics from subsidies could only be explained by a lack of knowledge about the medium's artistic potential. This lack of recognition for aesthetics-driven comics threatened the continuity of a Dutch comics culture. In countries like France, these comics were supported by the state, and this had, in Swarte's view, led to a growing supply of high-quality comics albums. For Dutch publishers, it was less risky to translate comics that had already been created elsewhere than to produce originally Dutch comics. This is one of the reasons why the majority of the comics albums available in the Netherlands are translations from French.[3] Swarte succeeded in convincing FBKVB, and since 1998 innovative comics artists have been able to get subsidies from them. In the first years of this new form of support for comics, he was appointed to the role of FBKVB's comics expert.

In their publishing policy, O&B varied comics that are really innovative and aesthetics-driven (some of which they know will not turn out to be bestsellers) with titles by already established artists that appeal to a larger audience. With the profits from the popular comics they could 'subsidize' the more experimental books (in other words, they apply the often-used strategy of internal subsidy).

O&B introduced many young Dutch comics artists to a broader audience. Prior to its existence, artists such as Peter van Dongen, Guido van Driel, Mark Hendriks, Maaike Hartjes, Marcel Ruijters, and Wasco had only appeared in small press publications. Many of the O&B albums created by these artists were praised by comics critics in general newspapers and magazines, as well as in fan magazines. Also worth mentioning is the fact that a number of O&B artists (among others, Peter van Dongen, Guido van Driel, Maaike Hartjes, and Mark Hendriks; source: Venema 2005) were supported financially by the subsidies from FBKVB, and from the Foundation for Art and the Public Domain (SKOR: 'Stichting Kunst en Openbare Ruimte'). Later, O&B/Scratch artists such as Aimée de Jongh also received financial support from the Dutch Foundation for Literature ('Nederlands Letterenfonds').[4]

Swarte also designed the interior of the Musée Hergé in Louvain-la-Neuve in Belgium, a museum dedicated to *Tintin* and Hergé which opened its doors in 2009.

Appendix II

In 2012, Joost Swarte earned the Marten Toonder Prijs, the most prestigious, state-financed, award for a Dutch comics artist, for all his artwork and his contributions to the world of comics.

In 2014, after O&B and De Bezige Bij had split, Wiebe Mokken started the new comics publisher Scratch, and Joost Swarte fulfilled the same role as adviser as he had done before for O&B. He also co-funded the comics magazine *Scratches*, which existed until 2018.

In 2019 and 2020, Swarte had a big exhibition called Joost Swarte Everywhere ('Joost Swarte overal') devoted to his work, in the Kunsthal in Rotterdam, to celebrate his 50-year jubilee as comics artist, designer, and architect.

With his posters, silkscreens, solo exhibitions in museums, the book *Hors Série*, and the catalogue *Plano*, Joost Swarte definitely wanted to show that what he made was fine art, and to guarantee that it was accepted as such.

He took the initiative to compile albums, organize exhibitions and comics festivals, publish monographies and catalogues about his work, and comic albums by others, and then looked for cooperation with museums, publishers, art experts, and other institutions. As an individual artist, he invited experts to write introductions for his books and catalogues, as a part of the symbolical production of his art (Bourdieu 1983, 1996). He became an expert himself, and in this role succeeded in getting recognition for 'artistic' comics from the governmental art institution FBKVB. Since this recognition, comics artists published by O&B, Scratch, and other artist-oriented publishers have been supported financially by FBKVB and the Dutch Foundation for Literature. Without these grants, many of the best Dutch comics that have appeared since 1998 probably would not have been produced. The publishing lists of O&B and Scratch would have been narrowed down to translations of foreign comics albums and graphic novels.

Swarte's knowledge of, and involvement in, other, more established forms of art than comics turned him into a link between different art worlds, some far more institutionalized than others. According to Becker (1982), such figureheads are necessary for a new art world to become institutionalized. Swarte's expertise was one of the factors that led to legitimacy and institutionalization of artistic comics in the Netherlands, albeit on a small scale, and not yet comparable with that of other visual arts.

Notes

1 Based on updated parts from De Vries (2014).
2 For a recent overview of Joost Swarte's life, see his biography by Wijndelts (2024) (in Dutch).

3 On average, fewer than 15% of the comic albums that appear on the Dutch market every year are originally Dutch (De Vries 2010).
4 Among many others, Scratch published the Dutch-language versions of graphic novels by Aimée de Jongh, who at this moment is probably the only other internationally well-known Dutch comics artist, especially after her comics adaptation of William Golding's *Lord of the Flies* was published in 2024, in 25 countries at the same time.

Bibliography

9e Kunst. 2019. 'Kunsthal Rotterdam viert jubileum Joost Swarte met grote expositie'. https://9ekunst.nl/2019/08/24/50-jaar-joost-swarte-te-zien-in-de-kunsthal/.
Becker, H.S. 1982. *Art Worlds*. Berkeley: University of California Press.
Bourdieu, P. 1983. 'The field of cultural production, or: the economic world reversed', translated by Richard Nice. *Poetics* 12: 311–356.
Bourdieu, P. 1996. *The Rules of Art: Genesis and Structure of the Literary Field*, translated by S. Emanuel. Cambridge: Polity Press.
Brok, H. 1980. 'Joost Swarte: Van Modern Papier tot Modern Art.' *Stripschrift* 133.
Brok, H. 1984. 'Het pregnante tekenen: De klare lijn van Joost Swarte.' *Vrij Nederland, Zomerboekenbijlage*, July 21.
Brok, H., E. Pommerel, and J. Swarte. 1977. *De klare lijn. Vierde schrift. Vol. 5 of Achtergronden van het beeldverhaal*. Rotterdam: Rotterdamse Kunststichting.
Daalder, M. 1992. 'Joost Swarte: De Twijfel Voorbij'. In: M. Daalder (ed.), *Stripjaar 1991*, 84–96. Amsterdam: Sherpa.
De Kruijf, T. 2010. 'De Bezige Bij neemt Oog & Blik over.' *Stripschrift* 408.
De Vries, R. 2006. Interview with Hansje Joustra. Amsterdam, May 16.
De Vries, R. 2006. Interview with Joost Swarte. Haarlem, June 12.
De Vries, R. 2010. 'Vernieuwing in de Nederlandse strip: stigma's en etiketten'. In: Z. Hrnčiřová, K. Mercks, J. Pekelder, E. Krol, and J. Ultzen (eds.), *Praagse Perspectieven* 6, 131–152. Praag: Universitaire pers.
De Vries, R. 2014. 'Balancing on the "Clear Line": between Selecting and Being Selected. Independent Comics Publishing in the Netherlands: the Case of Joost Swarte and Oog & Blik.' In: C. Dony, T. Habrand, and G. Meesters (eds.), *La bande dessinée en dissidence. Alternative, indépendance, auto-édition/Comics in Dissent. Alternative, Independence, Self-Publishing*, 113–125. Liège: Presses Universitaires de Liège.
Dohmen, T. 1998. 'Strips met een eigen koers.' *Boekblad* 46, November 13.
Hefting, P. 1987. 'Te veel om op te noemen. Notities over het werk van Joost Swarte'. Introduction to: J. Swarte, *Plano*, pp. I–XII. Amsterdam: De Harmonie en Het Raadsel.
Kousbroek, R. 1984. 'De klare lijn van getekende literatuur: Cartoons van Joost Swarte.' *NRC Handelsblad*, June 1, Cultureel Supplement.
Lambiek Comiclopedia. 2024. 'Joost Swarte'. https://www.lambiek.net/artists/s/swarte1.htm.
Lecigne, B. 1983. *Les héritiers d'Hergé*. Brussels: Editions Magic Strip.

Lecigne, B. 1984. 'Lecture'. Introduction to: J. Swarte, *Swarte, Hors série*, pp. 9–14. Paris: Futuropolis, and Amsterdam: Het Raadsel.
Nieuwenhuis, J. 1998. 'Joost Swarte: Het handschrift is de taal van de tekenaar.' *Zozolala* 100.
Peniston, D. 2006. 'Joost Swarte Interview.' *The Comics Journal* 279.
Sanders, R. 2009. 'Oog & Blik en De Bezige Bij slaan handen ineen.' *Stripschrift* 398.
Scratch. 2024. https://scratch-books.com/.
Swarte, J. 1980. *Modern Art*. Amsterdam: Real Free Press.
Swarte, J. 1984. *Swarte, Hors série*. Paris: Futuropolis, and Amsterdam: Het Raadsel.
Swarte, J. 1987. *Plano*. Amsterdam: De Harmonie and Het Raadsel.
Swarte, J. 1998. 'Wat is er mis met de Nederlandse strip?' *Trouw*, June 6.
Swarte, J. 2004. *Leporello*. Amsterdam: Oog & Blik en De Harmonie.
Swarte, J. 2011. *Joost Swarte bijna compleet*. Amsterdam: Oog & Blik en De Bezige Bij.
Venema, T. 2005. *Je krijgt geen geld, maar tijd. Een onderzoek naar subsidievertrekking aan striptekenaars door het Fonds BKVB*. Master's Thesis, University of Groningen.
Wijndelts, W. 2024. *Sleutelmomenten – Joost Swarte*. Amsterdam: Das Mag.

Index

Note: Information in figures and tables is indicated by page numbers in *italics* and **bold**, respectively.

aesthetic logics 36–37
Aire Libre 30
album format 5
anime 12
Art Moderne, L' 54
Asterix 8, 11

Belgium: history of comics in 7–8; readers in 13; sales in **10,** 11; *see also* Flanders; Wallonia
Bessy 7–8, 15n5
Bible 49
Bommel, Olie B. 9
Bries (publisher) 35–36

Calvin, John 49
Casterman (publisher) 30
Catholicism 48–52, *50,* **51**
Charlie Mensuel (magazine) 54
Cieslewicz, Roman 54
Circus (magazine) 32
Cocktail Komix 54

Dargaud (publisher) 8, 11, 33
De Bezige Bij (publisher) 9, 35, 56, 58
De Harmonie (publisher) 55–56
democratization, of culture 6
demographics, reader 6
Drukwerk (publisher) 55
Dupuis (publisher) 7, 25, 28–31, *29,* 31, 36, 43–44

Dutch Funds for Visual Arts, Design and Architecture ('Fonds voor Beeldende Kunsten, Vormgeving en Bouwkunst'— FBKVB) 57–58

education level, comic reading and 51

FBKVB *see* Dutch Funds for Visual Arts, Design and Architecture ('Fonds voor Beeldende Kunsten, Vormgeving en Bouwkunst'— FBKVB)
Flanders 1, 7–8; readers in **12,** *13*; religion in **51**; sales in **10**
France: history of comics in 6–8; production in 14, *14*; readers in **12,** 13, *13,* 14; sales in **10,** 11
Futuropolis 54

GBL *see* Groupe Bruxelles Lambert (GBL)
Germany 8
Glénat (publisher) 11, 30, 32–34, 36, 44
Glénat, Jacques 32
graphic novel 5–6
Groot, Jaco 56
Groupe Bruxelles Lambert (GBL) 30, 43

Hachette 30
Hergé 7–8, 53, 57
Héritiers d'Hergé, Les (Lecigne) 54

Herman, Paul 33
Het Raadsel (publisher) 55–56
history, of comics 5–10, **10**
Humanoïdes Associés, Les (publisher) 30, 32, 54

identity, niche 20
IL *see* institutional logics (IL)
institutional logics (IL) 2–3, 19–20
internet 11

Japan 11
Joustra, Hansje 55–56

Kana 11

Lang, Jack 56
Lecigne, Bruno 54
legitimacy 20
Leny presenteert (magazine) 53
logics: market 46; of publishers **37**; *see also* aesthetic logics; institutional logics (IL)
Lombard (publisher) 7

manga 1, 12, 33–34
Marten Toonder Prijs (award) 58
Marvel 1
Média Participations (MP) 30, 44
Modern Papier (magazine) 53
Mokken, Wiebe 34, 58
MP *see* Média Participations (MP)

Netflix 12
Netherlands: history of comics in 8–9; production in 14, *14*; readers in **12**, *13*, 14; religion in **51**; sales in **10**
New Yorker, The (magazine) 54

O&B *see* Oog & Blik (O&B) (publisher)
OE *see* organizational ecology (OE)
Oog & Blik (O&B) (publisher) 34–36, 56–58
organizational ecology (OE) 2–3, 20–21

Pilote (magazine) 8
Poes, Tom 9
practices, defined 19
production *14*, 14–15

Protestantism 48–52, *50*, **51**
publishers: case studies 28–36, *29*; history of 5; logics of **37**; polymorphist 43–44; practices of **38**

Raw (magazine) 54
readers **12**, 12–14, *13*, 48–52, *50*, **51**
Reizen en Avonturen van Mijnheer Prikkebeen, De 26n1
religion, in reading of comics 48–52, *50*, **51**
Robial, Etienne 54–55

sales 9–10, **10**, 11–12
Sanoma (publisher) 32
Schulpen, Ria 35
Scratch (publisher) 34, 58, 60n2
SDCN *see* Strip Documentatie Centrum Nederland (SDCN)
Spiegelman, Art 54
Spirou (magazine) 7, 28, 30, 40n3
Stripdagen Haarlem (festival) 56
Strip Documentatie Centrum Nederland (SDCN) 23–25, 39n1
Suske & Wiske 7
Swarte, Hors série 54–55, 58
Swarte, Joost 34, 36, 53–58

Tango (publisher) 53
Tcho! (magazine) 33
Tintin 7–8, 53–54, 57
Titeuf 33
Toonder, Marten 8–9
Toonder Studios 8
Töpffer, Rodolphe 26n1

underground comics 6
United States 11

Vandersteen, Willy 7–8
van Hamme, Jean 30
Veçu (magazine) 32
Viz Media 34
VNU (publisher) 9, 25, 31–32, 36, 44

Wallonia 1, 11; readers in **12**, *13*, 14; religion in **51**; sales in **10**
Weber, Max 48
World Values Surveys (WVS) 48
WVS *see* World Values Surveys (WVS)